7931

D0250683

THE NEW COVENANT

ROBERT E. COLEMAN

CHRISTIAN OUTREACH
1528 WOODBINE COURT
DEERFIELD, ILLINOIS 60015

© 1984 by Robert Coleman
All rights reserved, including translation
Library of Congress Catalog Card Number:
 84-061740
ISBN: 0-89109-524-1
15248
First Printing, NavPress, 1984
Second Printing, NavPress, 1985
Third Printing, Christian Outreach, 1988
(Originally published by Fleming H. Revell
Company as *Written in Blood*, © 1972. Ninth
printing in 1981.)
More than 140,000 copies in all editions in print.
Unless otherwise identified, Scripture quotations
are from the *King James Version*. Other versions
used are the *American Standard Version of the
Revised Bible* (ASV), copyrighted 1901 and 1929
by the International Council of Religious Educa-
tion, and used by permission; *The Living Bible*
(LB), © 1971 by Tyndale House Publishers,
Wheaton, Illinois, and used by permission; the
New American Standard Bible (NASB), © The
Lockman Foundation 1960, 1962, 1963, 1968,
1971, 1972, 1973, 1975, and 1977; and the
Revised Standard Version of the Bible, copy-
righted 1946, 1952, © 1971, 1973.

Printed in the United States of America

Contents

TO
my students
who have prayed with me
over the open Bible

Author

Dr. Robert E. Coleman is a professor of Evangelism as well as Director of the School of World Mission and Evangelism, and chairman of the Department of Mission and Evangelism at Trinity Evangelical Divinity School. He is a graduate of Southwestern University, Asbury Theological Seminary, Princeton Theological Seminary, and received the Ph.D. from the State University of Iowa.

Dr. Coleman's ministry centers on life-style evangelism and discipleship, a concern that he carries over into theological education. After serving as a pastor for six years, he joined the faculty of Asbury Theological Seminary where he taught until his appointment at Trinity.

A well-known author and speaker, Dr. Coleman is a founding member of the Lausanne Committee for World Evangelization, and for many years served as Chairman of the North American Lausanne Committee. He is President of Christian Outreach Foundation, and has been President of the Academy for Evangelism in Theological Education. He has authored or edited nineteen books, including *The Master Plan of Evangelism, Songs of Heaven* and *Promise of Revival*. Translations of one or more of his books are published, or in the process of publication, in eighty-two languages, with English editions alone having a combined circulation of well over 4,000,000 copies.

My hope is built on nothing less
Than Jesus' blood and righteousness;
I dare not trust the sweetest frame,
But wholly lean on Jesus' name.
On Christ, the solid Rock, I stand;
All other ground is sinking sand.

When darkness veils His lovely face,
I rest on His unchanging grace;
In ev'ry high and stormy gale,
My anchor holds within the veil.
On Christ, the solid Rock, I stand;
All other ground is sinking sand.

His oath, His covenant, His blood,
Support me in the whelming flood;
When all around my soul gives way,
He then is all my hope and stay.
On Christ, the solid Rock, I stand;
All other ground is sinking sand.

When He shall come with trumpet sound,
O may I then in Him be found
Dressed in His righteousness alone,
Faultless to stand before the throne.
On Christ, the solid Rock, I stand;
All other ground is sinking sand.

EDWARD MOTE

Foreword

A modern man tends to be too squeamish to talk about the blood of Christ. He finds the phrase disquieting—even repellent. Some years ago I received an angry letter from a lady who had been in church the previous Sunday. We had sung a hymn about Christ's blood. "A hangover from primitive blood rituals," she called it.

Certainly the vocabulary of "blood" in the Bible needs to be rightly understood. Startling expressions like "drinking Christ's blood" and "washing our robes" in the blood of the Lamb are dramatic figures of speech. They are symbols to be interpreted rather than pictures to be imagined.

So there is great need for Dr. Coleman's book. He describes it modestly as "devotional," but it is more than this. It is a thorough study of a fundamental Biblical truth, clearly written and well documented, which cannot fail to enlighten the mind and warm the heart of every Christian reader.

J. R. W. STOTT
Rector of All Souls Church
Langham Place, London

Angels rejoice in Jesus' grace
And vie with man's more favored race:
The blood that did for us atone
Conferred on you some gift unknown:
Your joy through Jesus' pains abounds,
Ye triumph by His glorious wounds.

Him ye beheld, our conqu'ring God,
Returned with garments rolled in blood!
Ye saw, and kindled at the sight,
And filled with shouts the realms of light;
With loudest hallelujahs met,
And fell, and kissed the bleeding feet.

Ye saw Him in the courts above
With all His recent prints of love—
The wounds!—The Blood! Ye heard its voice
That heightened all your highest joys;
Ye felt it sprinkled through the skies,
And shared that better sacrifice.

Not angel tongues can e'er express
Th' unutterable happiness;
Nor human hearts can e'er conceive
The bliss wherein through Christ ye live;
But all your heaven, ye glorious powers,
And all your God, is doubly ours!

CHARLES WESLEY

AND HE WAS CLOTHED WITH A
VESTURE DIPPED IN BLOOD: AND HIS
NAME IS CALLED THE WORD OF GOD.
REVELATION 19:13

Introduction

Communication is very much in our thinking today. How does one get across ideas to another person? Not just capture attention, but be heard and correctly interpreted? Little wonder that a credibility gap often exists between what is said and what is understood!

The difficulty is even more apparent when dealing with the intangible realities of the inner man. How do we tell a person that we love him? And how do we make known in this material world the spiritual dimensions of life and immortality? Most of all, how do we grasp the meaning of God? So infinite is the gulf between His absolute perfection and our finite experience that we might wonder how He could get through to us. Can we then ever be sure of eternal truth?

SOUL LANGUAGE

This is a problem that the Bible honestly seeks to answer. It is the story of God's action in making Himself and His purposes known. Since He is addressing men, not angels, He speaks in a manner that creatures of earth can best understand. The physical grandeur of nature, the unfolding events of history, the voices of Spirit-anointed prophets—all are summoned to convey His message. But supremely He speaks in the person of His own Son, Jesus Christ, the Word of God made flesh and living among us.

In bringing us to see the nature of His life and mission, God clothes His Word in concepts with which we can identify our spiritual quest. One of the most significant of these mediums is the blood. This physical substance is so closely related to the mystery of life and death that it only naturally becomes a symbol of religious expression.

There is no language more universal nor more ancient.[1] From time immemorial, people from every culture of the world have used the blood to speak those unutterable feelings of the soul which all of us know. As such, it is a common ingredient of man's aspirations beyond himself. Doubtless the blood has often been misused—and its meaning grossly perverted—but it is still there to speak of the ceaseless effort to communicate in another realm of reality.[2]

We should not be surprised then to note the frequency with which the blood is mentioned in the Bible. Altogether there are 460 specific references.[3] If related concepts are counted, such as *altar, sacrifice, offering, covenant, atonement,* and many others, the total would be multiplied many fold. In fact, I doubt if there is a page in the Bible that does not have some allusion to the blood. It is the scarlet thread that weaves the whole scope of revelation into one harmonious witness to the drama of redemption.

THE BLOOD OF CHRIST

When seen in its reference to Christ, the blood represents the very essence of holy love. It is the drink that gives eternal life. It is the key that grants entrance into the inner sanctuary. It is the bond of the everlasting covenant through which we are made perfect to do God's will. It is the means of our justification, redemption, reconciliation, sanctification, and every other benefit of the cross.

Probably no word in the inspired Book of God more graphically reveals the purpose of our Lord's coming to this earth. So interrelated are the two that when Christ returns in His majesty, He will be "clothed with a robe dipped in blood" (Revelation 19:13, NASB). It would seem that God has ordained His appearance this way because it typifies most clearly His work among us.

The same verse goes on to say: "And His name is called The Word of God." Here the blood-drenched apparel of Christ is linked with the revelation of Himself. Ultimately the Word of God and the blood of the Lamb are inseparable. Surely a diligent study of this truth will help us understand better the loving Savior in whom God's Word lives.

DESIGN OF THE BOOK

That is the purpose of this book. It seeks to penetrate the deeper meaning of the blood as finally incarnated and sacrificed in the Person of Jesus the Messiah.

I recognize that the subject is far too vast to ever complete. There are riches here that only eternity can unfold. Seeing them all is like trying to count the stars. The more we scan the heavens, and the greater the magnitude of our telescope, the more innumerable the stars appear. But we will

not let our limited comprehension keep us from gazing upon the wonder of what we can see.

The book is designed as a devotional guide to your personal study of the blood. Chapters are divided into short meditations to facilitate reading at brief intervals. Questions for thought follow each section. The hope is that you will ponder prayerfully what this concept means in your life.

SOURCES OF INFORMATION

In my own desire for understanding, I have traced the blood through the Bible, book by book, verse by verse. Every reference has been examined in its context. In turn, an effort has been made to interpret each passage in the light of God's saving purpose finally disclosed in Christ.

Numerous secondary sources also have been consulted. Though there are very few scholarly works addressed specifically to this theme, there is no want of material in related areas of study. Many of these resources are cited in the footnotes to aid the student who might want to pursue the subject further.

If I were to select one book of particular helpfulness, I think that it would be Andrew Murray's collection of sermons, *The Power of the Blood of Jesus and The Blood of the Cross.* [4] This little volume does not have the academic precision of some other works, but its simple, practical, adoring witness reflects the mind of one who has thought long on this subject.

Doubtless the greatest insight to the blood, outside of the Scripture, is found in the great hymns and gospel songs of the church. These poems of praise and testimony reflect feelings of people keenly sensitive to the things of God. Have you noticed how often the blood is mentioned? I think that it

was this realization that first awakened my desire to know what the term meant. Selected stanzas from some of these songs are scattered throughout this study.

FOOTPRINTS TO FOLLOW

Not long ago, I heard a missionary tell about a boy who appeared at a mission hospital in Kenya with a gaping wound in his foot. He had been accidentally injured while cutting grass far out in the jungle. Part of his heel was cut off. Without waiting to inform anyone of the mishap, the two boys set out across country to find the mission station where they had heard medical help was available. Every time the little foot touched the sandy earth it left a faint trace of blood. The journey was long and difficult, but at last they arrived.

After a time the boy's mother appeared. The doctors were surprised that she found the way. There were no well-defined trails, and she had never made the trip before.

"How did you do it?" she was asked. The dear woman, overjoyed to be with her child, replied, "Oh, it was easy. I just followed the blood!"

In a much more profound sense, that is how we come to Jesus. The path is sometimes rough and may lead through many trials, but we need not fear getting lost. All we have to do is follow His footprints. They are easy to find, for each one is stained with blood. The blood will always lead to the Savior.

> I must needs go on in the blood-sprinkled way,
> The path that the Savior trod,
> If I ever climb to the heights sublime,
> When the soul is at rest with God.

> JESSIE BROWN POUNDS

NOTES:

1. Information respecting ceremonial rites involving blood in primitive societies may be found in almost any standard work on cultural anthropology. Texts by John Beattie, A.L. Kroeber and Robert H. Lowie are examples. Any number of religious authorities also touch upon the subject, such as Robert Smith, S.I. Curtis, J. Peterson, W.C. Graham, H.G. May and Maurice H. Farbridge. Probably some of the most extensive research in this field has been done by H. Clay Trumbull, published in *The Blood Covenant* (London: George Redway, 1887); *The Threshold Covenant* (New York: Charles Scribner's Sons, 1896); and *Studies in Oriental Social Life* (Philadelphia: Sunday School Times, 1907). The anthropological information in these books may need to be updated, but it is still very useful material compiled by competent Christian scholars.

2. Some authorities have conjectured that at one time there may have been a clear revelation as to the spiritual significance of the blood. This might account for the priest and sacrifice as universal facts. However, if such was the case, its meaning was soon lost. Men still used blood in worship, but the spirit was perverted. Thus what was intended to be a blessing became a curse. Whether there is any merit in this theory, I do not know. But it does appear that only in the Bible do we get an adequate revelation of the blood's meaning. The uniqueness of the early Israelites' use of the blood as contrasted with the religious practices around them is confirmed by the research of many scholars, such as Dennis J. McCarthy in "The Symbolism of Blood and Sacrifice," *Journal of Biblical Literature*, LXXXVIII, II, June, 1969, pp. 166-176; and Harold H. Rowley, "The Meaning of Sacrifice in the Old Testament," *Bulletin of the John Rylands Library*, XXXIII, I, September 1950, pp. 74-110.

3. Of these references, 362 are in the Hebrew and 98 in the Greek. Approximately two-thirds of the books in the Bible are included. The word occurs most often in Leviticus and Ezekiel in the Old Testament, and Hebrews and Revelation in the New Testament.

4. Andrew Murray, *The Power of the Blood of Jesus and The Blood of the Cross* (London: Marshall, Morgan & Scott, 1951). First published in 1935 in separate volumes, this edition brings the two together under one cover. Another significant work, less comprehensive, is *C.H. Spurgeon's Sermons on the Blood and Cross of Christ* (London: Marshall, Morgan & Scott, 1961). A. Paget Wilkes' *The Dynamics of Redemption or the Blood of Christ* (London: Japan Evangelistic Board, 1924) also is worthy of note.

Spirit of faith, come down,
 Reveal the things of God;
And make to us the Godhead known,
 And witness with the blood.
'Tis Thine the blood to apply,
 And give us eyes to see,
Who did for every sinner die,
 Hath surely died for me.

No man can truly say
 That Jesus is the Lord,
Unless Thou take the veil away,
 And breathe the Living Word.
Then, only then, we feel
 Our interest in His blood,
And cry, with joy unspeakable,
 "Thou art my Lord, my God!"

O that the world might know
 The all-atoning Lamb!
Spirit of faith, descend, and show
 The virtue of His name:
The grace which all may find,
 The saving power, impart,
And testify to all mankind,
 And speak in every heart.

Inspire the living faith,
 Which whosoe'er receives,
The witness in himself he hath,
 And consciously believes;—
The faith that conquers all,
 And doth the mountain move,
And saves whoe'er on Jesus call,
 And perfects them in love.

CHARLES WESLEY

EXCEPT YE EAT THE FLESH
OF THE SON OF MAN, AND DRINK
HIS BLOOD, YE HAVE NO LIFE IN YOU.
JOHN 6:53

1
The Giving of Life

Who is not familiar with the miracle of a blood transfusion? It is the method of transferring blood from one person to another. Through this physical process there is literally a transference of life. Recognizing this physical phenomenon, we should not think it strange that blood should be associated with spiritual life given to us through the atoning death of our Lord. Here then is a good place to begin our study.

LIFEBLOOD

Life—that mysterious quality which science has never been able fully to define—immediately brings to mind the blood.

This vital fluid courses through the flesh of all higher forms of animate existence, bringing the food and oxygen that sustain bodily functions. The blood also fights disease that enters the body and assists in getting rid of waste products.

In an average human being, it circulates twice every minute. As the heart pumps the blood through the network of arteries, capillaries and veins, every cell in the body is continually supplied and cleansed. No part of the flesh can live without being in contact with this throbbing stream of life.

Most adults have five to seven quarts of this red substance made up of plasma, corpuscles and platelets. Every cubic millimeter of the blood—a speck the size of a pinhead—has in it approximately 5,500,000 living cells. The cells live 110 to 120 days. To replenish those cells which have fulfilled their life function, the body manufactures almost 2,000,000 new cells every second.[1]

Truly it is amazing! Though medical research has probed deep into its mystery, there is still locked within its elements a secret known only to the Creator. Yet whatever remains hidden, it is clear that the blood is the essential ingredient of physical life. In a very real way life becomes visible through the blood.

We can understand then the Bible's speaking of "blood of your lives" or "lifeblood" (Genesis 9:5; cf., 1 Chronicles 11:19, RSV; Isaiah 63:3, ASV). The phrase "born of bloods" conveys the same idea of human life (literal translation of term in John 1:13; cf., Acts 17:26). There are rare occasions when the words *blood* and *life* can be used interchangeably, as in Leviticus 19:16 when we are told not to "stand against the blood" of our neighbor. Here blood clearly refers to the man's life, and is so translated in some versions (RSV, NASB).

In the same vein, since the heart is the center of the blood circulatory system, it becomes the epitome of life. The

term is used in this way hundreds of times in the Bible to designate the total personality of man. Hence it can be said that out of the heart proceed evil thoughts (Matthew 15:19); sinners should rend their hearts (Joel 2:13); we must believe with our heart (Romans 10:10); or God will take away the stony heart and give a new heart (Ezekiel 11:19).

Dr. Christian Barnard tells of one of his heart-transplant patients asking to see the removed organ. Obligingly, the doctor brought from the laboratory the large bottle where the old heart had been placed. As the man looked at the big muscle which once pumped life through his body, the famed surgeon suddenly realized that this was the first time in human experience that a person had ever seen his own heart. It was indeed an historic moment. But for the patient the sensation must have been even more moving, for the old heart was worn out. Had it not been replaced, life would soon have been extinct. After a long pause, the grateful man up and said, "I'm glad that I don't have that old heart anymore."

Certainly we are no better than our heart, whether it relates to the body or the soul. Where the heart is weak and the blood diseased, life is in danger. But where the heart is strong and the blood is pure, life is full of health and over-flowing with joy. Christ wants to impart this to everyone.

> What can wash away my sin?
> Nothing but the blood of Jesus;
> What can make me whole again?
> Nothing but the blood of Jesus.
>
> Oh! Precious is the flow
> That makes me white as snow;
> No other fount I know,
> Nothing but the blood of Jesus.
>
> ROBERT LOWRY

> Why is there a natural relationship between life
> and blood?
> What does Paul mean when he prays that Christ
> may dwell in our heart? Ephesians 3:17.
> What is a true heart according to Hebrews 10:22?

SANCTITY OF BLOOD

Life comes from God, so it is only natural that the blood
(without which there would be no life) be regarded with
reverence. Anything so related to the soul would invoke deep
feelings of solemnity and awe—even more so because of its
sacred association in worship.

For this reason God commanded that the Israelites not
use blood for food. The flesh could be eaten only after the
blood was completely drained from it (Leviticus 19:26). "For
the life of the flesh is in the blood: and I have given it to you
upon the altar to make an atonement for your souls . . .
therefore I said unto the children of Israel, You shall eat the
blood of no manner of flesh: for the life of all flesh is the blood
thereof" (Leviticus 17:11,14; cf., 3:17; 7:26-27; Deuteron-
omy 12:23; Genesis 9:4).

To violate this rule meant expulsion from the Jewish
community unless there was atonement for the sin (Leviticus
7:27; 17:10,14; 1 Samuel 14:32-35). This applied to all blood
whether or not it was used in some form of sacrifice. For
regardless of its religious application, the blood was the
substance through which spiritual sacrifice was offered to
God.

So zealously was this law regarded among the Jews that
even in the early church, Gentile Christians were asked by
the Jerusalem Council to refrain "from things strangled and

from blood" (Acts 15:20; cf., 21:25).

As sacred as this rite was in Judaism, circumcision of Gentiles was not insisted upon, but the prohibition about drinking blood was something too deeply engrained in Jewish thinking to disregard. Apparently it was felt that this accommodation of the Gentiles would facilitate social relations with their Jewish brethren. Today, of course, the orthodox Jew still will eat only Kosher meat, that is, meat which is without blood and has been slaughtered according to their custom.

In ancient Israel, not only was the blood to be taken from any beast or fowl before it could be eaten, but the law stipulated that the blood must be poured out on the earth "like water" and then covered with dust (Leviticus 17:13; Deuteronomy 12:16; 15:23; cf., Ezekiel 24:7). Returning the blood to the earth suggested that life was being given back to God, the Creator of the earth, while covering the blood with dust resembled the burial of a body.

God wanted to teach His people very early that the blood had a divine essence. It was the physical symbol of created life and death. In its highest sense, the blood spoke of Him who one day would give His own life for the world, the incarnate Son Himself. Though our primitive forebears could not visualize its ultimate message, still they knew that the blood belonged to God, and that somehow it was the means of their redemption.

Jesus' life and sacrifice gave to the blood its real meaning.[2] That is why, in any form, it was not to be treated lightly. This fluid in the fulness of time actually flowed in Emmanuel's veins. And one day, nearly two thousand years ago, that same blood drained out of His body on the cross. "God gave His breath to man in creation, and His blood for man on Calvary. He gave His blood because He had given His breath. Each was His very life."[3]

Lord of glory, Thou has bought us
 With Thy life-blood as the price,
Never grudging for the lost ones
 That tremendous sacrifice,
And with that has freely given
 Blessings countless as the sand,
To the' unthankful and the evil
 With Thine own unsparing hand.

ELIZA S. ALDERSON

Read 1 Samuel 14:31-35, noting the serious offense of the Israelites in eating flesh which had not been properly drained of its blood.

In the light of Leviticus 17:10-14 and Deuteronomy 12:23-24, why did God prohibit the eating of blood?

How does the sanctity of blood relate to Christ? What about your own blood?

LIFE GIVEN IN DEATH

Life given through the blood is taken in the shedding of blood; not in the sense that life is released from the flesh, but rather that life is brought to an end. It is finished; thus drained out of the body, blood means death.

Normally the term in Scripture has this reference. For example, to say of the saints that "precious shall their blood be" in God's sight (Psalm 72:14) is to assert the blessing of dying when life has been lived unto the Lord (Psalm 116:15). On the other hand, when the death of transgressors is described, "their blood shall be upon them" (Leviticus 20:9,

11-13, 16-17; 2 Samuel 1:16). Interestingly a cemetery is called a "field of blood" (Matthew 27:8; Acts 1:19).

One of the most graphic uses of the word is in connection with laws respecting murder. Life belongs to God who gave it, and He alone has the right to take it away. Hence, man is forbidden to shed "innocent blood" (2 Kings 24:4; Deuteronomy 19:10; Jeremiah 22:3). If it is done, the one "guilty of blood" must forfeit his own life in exchange (Numbers 35:27,33; cf., Genesis 9:6).[4] Shed blood cries out from the earth for revenge (Genesis 4:10; Isaiah 26:21). And God will not let the spilled blood of life which He gave go unrequited (Deuteronomy 32:43; Ezekiel 35:6; 36:18; Luke 11:50; Revelation 6:10; 19:2).

Jesus underscored this principle when He said that the blood of the prophets would be required of His generation (Luke 11:50-51; Matthew 23:30,35). How much more must His own death bring us under indictment, for the cry of the people still echoes in the heart of man: "His blood be on us, and on our children" (Matthew 27:25; cf., Acts 5:28).

When referring to Christ, invariably blood is shed blood. In the dictum of J. Belm, it is "like 'cross,' only another clearer expression for the death of Christ in its salvation meaning."[5]

This is particularly significant when interpreting the atoning work of our Lord. For it means that finally it is the sacrificial death of Christ, not His meritorious life, which gives us redemption,[6] yet it is by virtue of who He was in life that His death has eternal relevance. What He died for will never change. In the ages to come we will know Him as our loving Savior who gave His blood for us.

Thou has to death Thy holy body given,
Life to win for us in heaven.
By stronger love, dear Lord, Thou could'st not bind us,

Where of this should well remind us.
 Lord, have mercy on us.
Lord, Thy love constrained Thee for our good
Mighty things to do by Thy dear blood.
Thou hast paid the debt we owed,
Thou hast made our peace with God.
 Lord, have mercy on us.

MARTIN LUTHER

Why would God be an avenger of the blood of His
 servants?
Note Deuteronomy 32:43 and Psalm 9:12. How
 does this relate to Christ?
Why does the blood of Christ always have in it the
 virtue of His life given in death?
Is Christ's blood a symbol of life or death? What
 difference does it make when interpreting the
 atonement?

ONE FOR ANOTHER

Sacrifice brings the spiritual significance of the blood into
focus. It is a voluntary surrender of that which is most
precious to man in the earnest desire to establish communion
with God.[7] As such, true sacrifice expressed the highest
devotion of which man was capable. In the shed blood, life
was poured out unto death—nothing more could man give,
yet nothing less could God accept.

The act of worship was represented through the offering
of an animal substituted for the worshiper. To underscore its
vicarious nature, the innocent victim had to be the rightful

property of the sacrificer. If the person did not have a proper animal to offer, he could purchase one for the occasion. Whatever kind of animal was used, it had to be free of defects and considered "perfect" (Leviticus 22:21-24).

Having selected a fitting substitute, the individual brought it to the door of the tabernacle "before the Lord" (Leviticus 1:3; 4:4). There he put his sacrifice upon the altar so that it faced toward the Holy Place. Sometimes, assisted by the priest, he bound the animal to the altar horns.

The sacrificer then placed his hands upon the head of the offering while stating the reason for his sacrifice (Leviticus 1:4; 4:4). It was as though the person put away sin from himself and transferred it to the body of the helpless animal. If the sacrifice was brought by more than one person, each had to lay on hands. In certain public sacrifices for all the people, the "elders," as representatives of the congregation, laid on hands (Leviticus 4:15). On the Day of Atonement the High Priest himself laid on his hands for the people (Leviticus 16:21).

In most private offerings the person killed his own sacrifice. Public sacrifices were slain by the priests. The animal was always killed in a violent way, usually by slitting the throat with a sharp knife. Any animal that had died from natural causes, or that was torn by beasts, could not be used (Leviticus 22:8). The death had to be inflicted clearly as a consequence of its sacrificial purpose.

The shed blood was offered to God by the officiating priest. Depending upon the type of sacrifice, the blood was sprinkled upon the altar, thrown against the altar or poured out at its base. After the blood was applied, in some offerings, portions of the flesh could be eaten while other parts were burned on the altar.

It is immediately apparent our Lord's sacrifice is reflected in the blood-red altars of Israel—His blameless life,

the manner of His death, the nailing of His body to the cross—even in the way He offered His soul to God.

> Surely our griefs He Himself bore,
> And our sorrows He carried;
> But He was pierced through for our transgressions,
> He was crushed for our iniquities;
> The chastening for our well-being fell upon Him.

> ISAIAH 53:4-5, NASB

Dr. Robert G. Lee tells of an unforgettable experience he had the first time he visited Calvary on a tour of Israel. His excitement was such that he soon outdistanced his guide in climbing the hill. As he reached the summit and stood there at the very place where his Lord poured out His blood, the great preacher's emotions were so stirred that his body started to tremble. When at last the breathless guide caught up with him, he asked, "Sir, have you been here before?" For a moment there was a throbbing silence. Then in a whispered tone Dr. Lee replied, "Yes, I was here nearly two thousand years ago."

Beloved, we were all there nearly two thousand years ago. Jesus died in our place. As our Representative, He suffered for us, "the just for the unjust, in order that He might bring us to God" (1 Peter 3:18, NASB).

> "Man of sorrows," what a name
> For the Son of God who came
> Ruined sinners to reclaim!
> Hallelujah! What a Savior!

> Bearing shame and scoffing rude,
> In my place condemned He stood;

Sealed my pardon with His blood:
Hallelujah! What a Savior!

<div align="right">P.P. BLISS</div>

Read Leviticus 1:1-5 and 4:1-7. Put yourself in
this passage as if you were seeking forgiveness
from sin.

Meditate upon Isaiah 53:1-14. How did Philip use
this passage to show Jesus to the Ethiopian?
Acts 8:32-34.

What does it mean to say that Christ died for you?

FULFILLMENT OF PROMISE

The Old Testament sacrifices were a foreshadowing of the
perfect one to come—a setting forth in advance of "heavenly
things" (Hebrews 9:11, 23-25; 8:5; 10:1; Colossians 2:16-17).
In symbol and prophecy they spoke of that day when Christ
Himself would offer His blood on the cross.

Common sense would have taught the Jews that the
sacrifice of bulls and goats in themselves could never take
away sin (Hebrews 10:4). Had they made a lasting reconcilia-
tion for the people, they would have ceased to be offered. As
it was, the ceremonial public sacrifices had to be repeated day
after day, year after year.[8] Even the individual offerings had
to be reenacted as the occasion required. Although God
honored the sacrifices of believing Israelites, it was only by
reason of the promised Savior to which they all pointed.[9]

When Jesus came into the world, He said to the Father,

"Sacrifice and offering Thou has not desired,
But a body Thou has prepared for Me; . . .

'Behold, I have come
(In the roll of the book it is written of Me)
To do Thy will, O God.'"

HEBREWS 10:5,7, NASB; cf., PSALM 40:6-8

This quotation from the Psalm shows that Jesus understood His own incarnate ministry as the fulfillment of sacrifice from the beginning. It was not the slaughter of beasts that was desired by God. The Father wanted a life to be lived before Him in perfect obedience. Only such an offering could fulfill the intent of true sacrifice.

Thus Jesus clothed Himself with a "body" to do the will of God. By the miraculous conception in the womb of the virgin, the eternal Word assumed the likeness of man. Since we are "made of flesh and blood, He became flesh and blood too by being born in human form" (Hebrews 2:14, TLB; cf., 1 Corinthians 15:50; Galatians 1:16). His identity with us was complete.

Consider what this means. Jesus is no imaginary figure dreamed up by religious soothsayers, nor is He some ethereal deity removed from the harsh realities of this world. His life was for real. Like any of us, He knew the hardships of daily toil. He could feel the pangs of suffering and disappointment. And finally He bore in His body our death. As a member of the human family, we share together in the blood of the flesh.

His experience as a man enabled Him to be an understanding priest—One who was tempted in every respect as we are (Hebrews 4:15; cf., 2:17-18). But unlike the priests of old who had to offer up sacrifice daily for their sin (as well as for the sins of the people), Jesus as the perfect man offered up Himself once and for all (Hebrews 7:27).

Isn't it wonderful how a shadow disappears when the sun is directly overhead? So it is with the ancient sacrifices of

Israel. The brilliance of Christ's life has now appeared over all. The types are no longer necessary, for the pattern Himself has come. In Him our quest for peace is ended.

> Not all the blood of beasts,
> On Jewish altars slain,
> Could give the guilty conscience peace,
> Or wash away the stain.
>
> But Christ, the heavenly Lamb,
> Takes all our sins away—
> A sacrifice of noble name,
> And richer blood than they.
>
> ISAAC WATTS

Read Hebrews 10:1-10 and Colossians 2:16-17. In what sense is the Old Testament sacrificial system a shadow of good things to come?
How does the "flesh and blood" of Jesus identify Him with your situation? Why is this significant to you?

PARTAKING OF HIS BLOOD

The saving reality of Christ's life comes through appreciating the merit of His sacrifice. Jesus says: "He who eats My flesh and drinks My blood has eternal life; and I will raise him up on the last day. For My flesh is true food, and My blood is true drink. He who eats My flesh and drinks My blood abides in Me, and I in him" (John 6:54-56, NASB).

Clearly our Lord erases any illusion that there can be salvation apart from His atoning death. "Unless you eat the

flesh of the Son of Man, and drink His blood, you have no life in yourselves" (John 6:53, NASB).

But the question might be asked: Why did He invite us to drink His blood? How can this be done? Not only that, but was not the drinking of blood strictly forbidden by the law?

The answer immediately brings into focus the ultimate meaning of the blood in our experience. It is a way of objectifying a spiritual principle—a truth seen faintly in every sacrifice, but only fully disclosed in the personal ministry of Jesus Christ. Blood is the symbol of His death for us. To drink of this substance is to take into our heart the life-renewing power of the cross. It is to receive the grace of God. Not until the Giver of life had come could this invitation be extended. Only He who was to die as our perfect sacrifice could offer us the privilege of union with Himself.

Veiled in this infusion of life through death is the principle of the resurrection. That which is relinquished in the shedding of blood thus becomes the basis of a new creation in Christ.

Jesus explains that His life is transmitted by the Spirit. "It is the Spirit who gives life; the flesh profits nothing" (John 6:63, NASB). What the blood of Christ has accomplished for us, the Spirit of Christ effects in us. It might be said that the blood speaks of the life of Christ poured out; the Spirit speaks of His life poured in. In terms of our experience, then, the two flow together (Hebrews 10:29; Ephesians 2:13,18). The eternal Spirit who offered up the blood of Christ also breathes in us the power of that sacrifice (Hebrews 9:14).

There is an actual partaking of the divine nature (2 Peter 1:4). Jesus does not give us a mere philosophy of life or a code of ethics. He gives us Himself. The Christian life is not a creed or a dogma. It is participation in the very life of Him who loved us and gave His blood for us.

The figure of eating and drinking conveys the idea of a

feast. And, indeed, experiencing the transforming life of the Son of God is an occasion for celebration. And since we continually feed on Him, there is no end to this joy.

Faith is the means by which the Spirit makes it happen. It is to the soul what eating and drinking is to the body. In this analogy, too, we see that saving faith is simply taking Christ at His word and living by His flesh and blood. Here is the secret of life, real life, resurrection life, life now and life forever. Oh that we might drink deeply from this cup!

> Jesus, at whose supreme command
> We now approach to God,
> Before us in Thy vesture stand,
> Thy vesture dipped in blood.
>
> Now, Lord, on us Thy flesh bestow,
> And let us drink Thy blood,
> Till all our souls are filled 'below
> With all the life of God.
>
> CHARLES WESLEY

Read carefully John 6:53-56. What does Christ refer to when He speaks here of His blood? What is the secret of abiding in Christ? How would you define faith?

What is the relationship of the Holy Spirit to the blood of Christ? Note Hebrews 9:14 and 10:29.

THE GREAT DECISION

A little boy was told by his doctor that he could save his sister's life by giving her some blood. The six-year-old girl

was near death—a victim of a disease from which the boy had made a marvelous recovery two years earlier. Her only chance for restoration was a blood transfusion from someone who had previously conquered the illness. Since the two children had the same rare blood type, the boy was the ideal donor.

"Johnny would you like to give your blood for Mary?" the doctor asked.

The boy hesitated. His lower lip started to tremble. Then he smiled, and said, "Sure, Doc, I'll give my blood for my sister."

Soon the two children were wheeled into the operating room—Mary, pale and thin; Johnny, robust and the picture of health. Neither spoke, but when their eyes met, Johnny grinned.

As his blood siphoned into Mary's veins, one could almost see new life come into her tired body. The ordeal was almost over when Johnny's brave little voice broke the silence. "Say, Doc, when do I die?"

It was only then that the doctor realized what the moment of hesitation, that trembling of the lip meant. Little Johnny actually thought that in giving his blood to his sister he was giving up his life! And in that brief moment he had made his great decision![10]

In a way, that is the kind of decision we make in receiving Christ. It is a commitment unto death. Of course, the analogy breaks down when describing what our Lord did when He gave His blood for us, but at least it points up the nature of our response to His sacrifice. As we know our heart, we give all we are to Him. By this act of our will, through the Holy Spirit, there is a transfusion of life at the altar of God.

We hear a lot today about blood banks. They are depositories where blood taken from healthy donors is stored for future use. Through the adding of certain preservatives, and

the maintenance of the proper temperature, the blood can be kept for a relatively long period of time. When an emergency arises in which a transfusion is needed, a call to the blood bank usually will bring forth the desired supply of saving fluid. This is a marvel of modern science.

But how much more wonderful is the blood bank of Calvary! There in unlimited supply is the incorruptible blood of the Son of God. Its life-giving power is as strong today as it was when given at the cross. It matches every type, avails for every need, and is free to all who will receive it into their heart by faith.[11]

If for any reason your life has not known this divine transfusion, receive it now. Make your great decision. Offer yourself to Him, even as He has given Himself to you. And in this holy outpouring of life, your heart will feel the throb of the heart of God.

> Just as I am, without one plea,
> But that Thy blood was shed for me.
> And that Thou bidd'st me come to Thee.
> O Lamb of God, I come! I come!
>
> Just as I am, and waiting not
> To rid my soul of one dark blot,
> To Thee whose blood can cleanse each spot.
> O Lamb of God, I come! I come!

CHARLOTTE ELLIOTT

What is the secret of finding life as taught by Jesus? Matthew 16:24-26. How is this secret always implied in the blood?

In what sense is receiving Christ like a blood transfusion? How is it unlike?

What do we become in Christ? Note 2 Corinthians
5:17 and John 1:12.

NOTES:
1. William Dameshiek, "Blood," *The World Book Encyclopedia,* Vol. 2
 (Chicago: Field Enterprises Educational Corporation, 1964), pp. 324-
 328; William Dameshiek and Peter P.H. DeBruyn, "Blood," *Ency-
 clopedia Britannica,* Vol. 3 (Chicago: Encyclopedia Britannica, Inc.,
 1965), pp. 795-799.
2. Some contend that because of His virgin conception, Christ did not
 actually have human blood. The idea comes from the belief that the
 blood of a human body is formed in the fetus itself by the introduction
 of the male sperm, and therefore has no direct contact with the
 mother's body. According to this view, the mother supplies the devel-
 oping infant with the nutritive elements for the building of the body,
 but there is no actual interchange of blood between the child and the
 mother. If this is the case, then the blood in the physical body of Christ
 would be uniquely the very blood of God, while only His flesh was
 human. This position has been popularized by Dr. M.R. DeHann in
 his stimulating book, *The Chemistry of the Blood* (Grand Rapids:
 Zondervan, 1943), pp. 9-44. To support his view, Dr. DeHaan quotes
 from several recognized medical authorities. Without trying to dis-
 credit this position, I think that it is only fair to note that other medical
 doctors seriously question its validity. However, regardless of the
 biological nature of the situation, I see no reason why it should be an
 issue. The fact that Jesus was conceived by God would itself rule out
 the hereditary transmission of sin. I am inclined to believe that His
 human nature included both His flesh and blood, and both were
 equally free of any moral corruption.
3. S.D. Gordon, *Quiet Talks with World Winners* (New York: Fleming
 H. Revell Company, 1908), p. 24.
4. The judicial law stipulated that the nearest relative to the deceased was
 to become "the revenger of blood" (Numbers 35:19,21; Deuteronomy
 19:12-13). He was bound to execute retaliation himself if it lay in his
 power. After the murderer was slain, no further retaliation was permit-
 ted (Deuteronomy 24:16, 2 Kings 14:6). In the case of taking a life
 accidentally, the involuntary killer was permitted to flee for safety to
 one of the cities of refuge appointed for this purpose (Numbers 35:25;
 Deuteronomy 19:4). Killing in self-defense and the judicial execution
 of criminals were exempted from the penalties of shedding

blood, although proper atonement for the deed had to be made. Persons in authority incurred blood guilt when those for whom they were responsible committed murder (1 Kings 2:5-9; 31-33). Ultimately, of course, all blood guilt is dealt with by God Himself (Genesis 9:5; 1 Kings 2:32; Psalm 79:10; Job 16:18-21). What is set forth here may seem rather harsh to our permissive society today, but we must remember that the primitive tribes of Israel lacked many of the restraining influences of our culture. Had it not been for these carefully defined laws respecting blood revenge, it is possible that the people might have exterminated themselves. Nevertheless, God cannot ignore the desecration of that which is sacred. He must teach His people to reverence life. This does not argue for capital punishment in our day, but it does mean that we cannot treat casually any defilement of the blood. It is interesting that the word "avenger" means "kinsman redeemer" (Deuteronomy 25:5-10; Ruth 4:1-8). Jesus is our Kinsman Redeemer, and He will be our Avenger of blood (Isaiah 63:1-6; Revelation 14:14-20; 19:11-21).

5. Quoted by Leon Morris in "The Blood—Life or Death?" *Christianity Today*, II, 12, March 17, 1958, p. 8. A longer discussion of this issue by the same author may be found in, *The Apostolic Preaching of the Cross*, Third Edition (Grand Rapids: Wm. B. Eerdmans, 1965). The larger work is the best scholarly treatment of the subject that I have seen. Dr. Morris concludes that the blood in Scripture "signifies essentially the death." Other good presentations with this same conclusion may be found in A.M. Stibbs, *The Meaning of the Word "Blood" in Scripture* (London: Tyndale, 1954); H.E. Guillebaud, *Why The Cross* (London: InterVarsity, 1954); and the classic work of James Denney, *The Death of Christ* (New York: Eaton and Mains), to mention only a few.

6. Some eminent scholars insist that it is the life in the blood that effects atonement with God. The idea is that the blood itself possesses special energizing powers that are released in sacrifice. Carried over to the blood of Christ, this view suggests that it was the Lord's life, not His death, that became the means of our redemption. I appreciate the reverence of this position for the holiness of Christ's life, and this emphasis cannot be lost in any valid view of the atonement—but the fact remains that the reason the life of Christ has saving power to us is because by dying He dealt with the fatal necessities of our situation. Able discussions of the life view may be found in, among others, Trumbull, *The Blood Covenant;* Vincent Taylor, *The Atonement in New Testament Teaching* (London: Epworth, 1946); and B.F. Westcott, *The Epistle to the Hebrews* (New York: Macmillan, 1906).

7. The concept of sacrifice is treated in some degree by most Bible dictionaries, commentaries, and histories of Israel. Among works devoted especially to the subject is Alfred Edersheim's, *The Temple,*

Its Ministry and Services (Grand Rapids: Wm. B. Eerdmans, 1963). Although this volume was first published nearly a century ago, I believe that it is still unsurpassed for simplicity, reverence, and beauty of description. If brevity is desired, a good statement by an evangelical scholar is F.D. Kidner's, *Sacrifice in the Old Testament* (London: Tyndale, 1951); or the older work of W.W. Washburn, *The Gospel According to Moses;* or *The Import of Sacrifices in the Ancient Jewish Service* (Cincinnati: Walden and Stowe, 1883). Among the more critical studies of the subject are the works of Roland DeVaux, *Studies in Old Testament Sacrifice* (Cardiff: University of Wales Press, 1964); and Joachim Kraus, *Worship in Israel* (Richmond: John Knox Press, 1962).

8. Official public sacrifices prescribed by law would number altogether 1,273 a year (Numbers 28:1-29:39). If regularly observed, this would amount to almost 2,000,000 from Moses to Christ, apart from the countless millions of unnumbered individual offerings and additional public sacrifices. Though the sacrifices were usually neglected during periods of religious indifference—which were frequent—still the number of animals slain in sacrifice is staggering to imagine.

9. A good discussion of this point is by Howard E. Freeman, "The Problem of the Efficacy of Old Testament Sacrifices," *Journal of the Evangelical Theological Society,* XII, 2, Spring, 1969, pp. 73-79.

10. Told by Myron L. Morris, M.D., in *Coronet,* November, 1948.

11. I am indebted to Dr. DeHaan for the idea of this illustration, *Chemistry,* p. 43.

And can it be that I should gain
 An interest in the Savior's blood?
Died He for me, who caused His pain?
 For me, who Him to death pursued?
Amazing love! How can it be,
That Thou, my Lord, shouldst die for me?

'Tis myst'ry all, th' Immortal dies!
 Who can explore His strange design!
In vain the first-born seraph tries
 To sound the depths of love divine!
'Tis mercy all! let earth adore:
Let angel minds inquire no more.

He left His Father's throne above;
 (So free, so infinite His grace!)
Emptied Himself of all but love,
 And bled for Adam's helpless race;
'Tis mercy all, immense and free,
For, O my God, it found out me!

Long my imprison'd spirit lay,
 Fast bound in sin and nature's night;
Thine eye diffused a quickening ray;
 I woke, the dungeon flamed with light:
My chains fell off, my heart was free,
I rose, went forth, and followed Thee.

No condemnation now I dread,
 Jesus, and all in Him, is mine!
Alive in Him, my living Head,
 And clothed in righteousness Divine,
Bold I approach th' eternal throne,
And claim the crown, through Christ, my own.

 CHARLES WESLEY

2
The Pure Heart

There is a natural relationship between the blood of Christ and holiness of life. Both issue from the same heart. The beauty of this truth, particularly as seen in sacrifice, is the special focus of these meditations.

THE HOLINESS OF GOD

It has been said, "Show me your gods and I will show you your people." How true! For example, if we worshiped a god of brute force, as did the ancient Romans who worshiped Jupiter, we would expect the people to live a brutal life, for that was the kind of god they worshiped. Or if we worshiped a

god of immorality, as did the devotees of Baal and Astorath in the primitive cultures of the Middle East, we would expect the people to lead a sexually perverse life. That was the kind of god they worshiped. We never rise above our god.

But the God that we worship, the God of the Bible, the God and Father of our Lord Jesus Christ, is holy. He is of purer eyes than to behold evil (Habakkuk 1:13). *Holy, holy, holy* is the song that the celestial hosts perpetually sing in His presence. Everything about His nature is holy.

For this reason God says of His people, "You are to be holy to Me, for I the Lord am holy; and I have set you apart from the peoples to be Mine" (Leviticus 20:26, NASB; cf., 11:44-45; 19:2; 1 Peter 1:15-16). A father always wants his children to exhibit and reproduce his character. Being a God of love, it could be no other way.

Holiness as a term describes that which is separate from the common or profane. In any absolute sense, of course, God alone is without sin. The only holiness that man can have is by relationship to God. A holy person or *saint* is simply one who is set apart for Him—one owned by God. This setting apart is called *sanctification*.

It is not difficult to see how holiness became so closely associated with blood sacrifice. That which is corrupted must be separated from the God of life—it must die. The shedding of blood visibly executed this sentence, thereby disclosing the perfection demanded by a holy God. Yet in vindicating God's inviolable nature, the blood showed how He could be reconciled to man.

Without a blood-washed heart, no one in Israel could come into the divine Presence. This necessity extended even to the articles used in worship, including the sanctuary and its furnishings. So holy is God that mere proximity to contamination required purification.

An example is the way persons were regarded after

contact with a dead body. Because of the stain of sin associated with death, anyone who happened to be near a corpse was considered unclean—those who touched the body, those who lived in the house where it lay, those who entered the house, those who attended a feast for the dead, even those who walked on the grave. Not only were these persons defiled, but anything they touched was corrupted until purification was accomplished (Numbers 19:11-23; 31:19; Hosea 9:4). Similar laws related to persons who came in contact with leprosy (Leviticus 14) and other sicknesses (Leviticus 15). Doubtless these rites of ceremonial cleansing served a hygienic purpose since they involved the washing with water of everything that might have been contaminated, but the offerings of blood sacrifice in connection with the rituals clearly made them symbols of a deeper spiritual truth.

Underlying it all is the principle of holiness. As God put it, "You shall keep the sons of Israel separated from their uncleanness, lest they die in their uncleanness by their defiling My tabernacle that is among them" (Leviticus 15:31, NASB). Sin prevents fellowship with God. Where there is defilement of any kind, sanctification must be effected.

Our Lord's mission to the world was to fulfill this requirement. He "put away sin by the sacrifice of Himself" (Hebrews 9:26, NASB). "For by one offering He has perfected for all time those who are sanctified" (Hebrews 10:14, NASB). His blood now makes it possible for us to serve God without fear "in holiness and righteousness . . . all the days of our life" (Luke 1:75).

> O how sweet to trust in Jesus,
> Just to trust His cleansing blood;
> Just in simple faith to plunge me
> 'Neath the healing, cleansing flood!
> Jesus, Jesus, how I trust Him

How I've proved Him o'er and o'er!
Jesus, Jesus, precious Jesus!
O for grace to trust Him more!

LOUISA M.R. STEAD

Read Exodus 3:5 and Joshua 5:6. Why did God
want these men to take off their shoes?
What is holiness, and why is it essential to our life
in Christ? Leviticus 11:44, 1 Peter 1:15-16.
Note Hebrews 9:13-14 and 10:19-22. How can a
sinful man ever be holy?

A HOLY PRIESTHOOD

The offering of blood was peculiarly the privilege of the
priesthood. Others could kill the sacrifice, but except in rare
instances only the priest could present the blood to God.

The word *priest* conveys the idea of standing up for
another (Deuteronomy 10:8). As such, he was a mediator
between God and man (Hebrews 5:1). This was true whether
he was taking care of the sanctuary, teaching the law, deliver-
ing an oracle, or offering sacrifice.

Previous to the Mosaic code, the father was the priest of
his own family and officiated at the domestic altar. He was
succeeded at death by his firstborn son. But when the law was
introduced by Moses, a particular order of men was appointed
to this special service (Exodus 28:1-43).

These men had to remain detached from profane things
and were subject to very strict rules concerning purity (Levi-
ticus 21:4-23). In a unique way they represented in their
person the inscription that was engraved in the golden

breastplate of the High Priest—*Holiness to the Lord* (Exodus 28:36). Nothing could be allowed to bring reproach upon their ministry. Because of the possibility of defilement, they were not even to take part in funerals, except in the case of blood relatives (Leviticus 21:1-3).

Priests were invested with their office through the act of ministering in sacrifice (Leviticus 21:6). The term used to describe a priest's ordination means literally "to fill his hand." It seems to have reference to the way Moses in the beginning put into the hands of Aaron and his sons the parts of the sacrificial animals that were to be offered on the altar (Exodus 29:22-34; Leviticus 8:22-33).

The whole ritual of ordination was saturated with blood. In addition to the rituals of sacrifice, blood was taken from the altar and put on the tip of the priest's right ear, on the thumb of his right hand, and on the great toe of his right foot. Also the garments of the priests were sprinkled with blood (Leviticus 8:1-36; Exodus 29:1-46). So bloody was the ritual that on one occasion the sons of Levi were said to have ordained themselves because of the way they had slain three thousand rebellious Israelites (Exodus 32:25-29).

Special priestly robes were put on when they ministered at the altar (Exodus 28:43).[1] The High Priest particularly was clothed with elaborate garments. Interestingly, the Hebrew word for coat has the root meaning "to cover" or "to hide." It is the same word used in Genesis 3:21 where it says that God made coats of skin to clothe Adam and Eve. The basic robe worn by all priests offering sacrifice was pure white, representing the purity of God. It was as though they were clothed with His character. To approach God without this covering would bring fearful judgment.[2]

The only time in the Bible that a naked priest ever offered sacrifice acceptable to God was at Calvary. When Jesus was nailed to the cross, He was stripped of His clothes

(John 19:23). Yet this was the first time in our history that One had lived among us who was worthy in His own right-eousness. Christ needed no robe, for He was Himself the perfect Son of man; and as the High Priest of heaven after the unchangeable order of Melchizedek, He offered up His own blood.

His sacrifice has made a covering by which now we can come before God clothed with "garments of salvation" (Isaiah 61:10). Our robes are washed white in His own blood (Revelation 1:5, 7:14). Adorned with His righteousness we can all minister before the throne of heaven. Thus is fulfilled God's original plan in having for Himself a "kingdom of priests and a holy nation" (Exodus 19:6; cf., 1 Peter 2:9). Jesus has done it all.

> 'Twas He that cleansed our foulest sins,
> And washed us in His richest blood:
> 'Tis He that makes us priests and kings,
> And brings us rebels near to God.
>
> To Jesus, our atoning Priest,
> To Jesus, our superior King,
> Be everlasting power confessed—
> And every tongue His glory sing.
>
> ISAAC WATTS

Why was a priest required to lead such a separated life? How was he a representative of what all the people were in promise? Leviticus 21:6.

How is Christ like the Old Testament priest and how is He unlike him? Note Hebrews 4:14, 5:10, and 7:15-28.

What does a kingdom of priests imply?

THE HOLY ALTAR

The altar was the place where sacrifice was consummated. The term itself, used more than 400 times in the Bible, comes from a root meaning "to slaughter." It was here that the priest presented blood to God.

The first mention of a Hebrew altar is after the flood, when Noah offered sacrifices to God (Genesis 8:20). Subsequently, altars were built by Abraham, Isaac, Jacob, Moses, and Joshua. With the erection of the tabernacle,[3] a brazen altar was made for the outer court; and an altar of incense (sometimes called the golden altar) was placed before the veil in the sanctuary. The Ark of the Covenant adorned with the Mercy Seat also constituted an altar in the Holy of Holies. These altars were constructed on a more elaborate scale in the later temples.

In early tribal days the doorway of a house commonly was the altar since it was the entrance to family life. Here a sacrifice was offered in dedication of the house, and thereafter sacrifices were made on special occasions, such as the welcome of a guest. Following this custom, the altars of God were located at or near the door of His house of worship. It was the place where the people of God entered into His fellowship, peace, and security. As the entrance into the Presence of the Holy One, it was also the dividing line between the secular and the sacred. No one could come to God except by way of the altar.

Perhaps relating to this home concept is the early idea of the altar as a hearth. Here at this center of warmth and light, the family assembled and the functions of life were performed. The altar is God's hearth where the fire must always burn in witness to His consuming holiness and illuminating truth.

At other times the altar may be spoken of as a table

(Ezekiel 44:16; Malachi 1:7,12). In this figure of the family, the children of God are gathered for a feast. At this place of communion, they shared together in the riches of grace.

In it all, the altar was the symbol of God's presence. There the Lord appeared (Genesis 12:7; cf., 26:24-25). It was called by Jacob *El-Elohe-Israel,* meaning "God, the God of Israel" (Genesis 33:20); and by Moses *Jehovah-nissi,* meaning "the Lord is my banner" (Exodus 17:15, RSV). Here was the appointed place where God promised to come and bless His own (Exodus 20:24).

But first the altar, like every other article in worship, had to receive atonement through the blood, and each year on the Day of Atonement this dedication had to be renewed (Exodus 29:36-37; 30:10; Leviticus 8:15; 16:18-19). Once this place of sacrifice was hallowed through the blood, then whatever touched the altar became holy (Exodus 29:37).

The blood stained body of Christ is now our altar (Hebrews 13:10), "the same yesterday and to day and for ever" (Hebrews 13:8). He is our door into the house of God. He is our hearth upon which the sacrifice is consumed. He is our table around which the household of faith celebrates holy communion. What is more, the altar sanctifies the gift (Matthew 23:19). Resting upon Him—trusting only in His blood—the offering of our life is holy in His sight.

> When I approach Thine altar, Lord,
> May I this comfort cherish,
> That on the cross Thy blood was poured
> For me, lest I should perish.
> Thou didst for me God's law fulfill,
> That holy joy my heart might thrill
> When on Thy love I'm feasting.
>
> C.F. GELLERT

What did the altar represent? Why did it have to be sanctified through blood? Note Exodus 29:35-37.

In turn, why did laying a gift on the altar make the offering holy? Matthew 23:19.

Meditate upon Hebrews 13:8-13. How is Christ on the cross our altar?

SIN OFFERINGS

In the Old Testament, most blood sacrifices fell into one of three types. Of these, the most basic was the sin offering and the related trespass offering.[4]

These sacrifices were for sins committed through ignorance or weakness (Numbers 15:22-29), with the exception of certain kinds of ceremonial defilements (Leviticus 5:2-3; 12:6-8). Public sin offerings pertained to the nature of sin, and were brought on feast days for all the people (4:1-35; 6:24-30). They symbolized the general provision for redemption in the blood. Sin offerings were also presented in special circumstances by individuals who needed purification. The trespass or guilt offerings were directed chiefly to worship for which restitution was required (5:1-6:7). In this case, the offering was made only after the proper satisfaction was done.

Premeditated, deliberate violations of the Law, called sins "with a high hand," were not dealt with in the ceremonial sacrifices. These included such offenses as murder (Exodus 21:12), adultery (Deuteronomy 22:22-23), Sabbath breaking (Numbers 15:32), and most forms of sacrilege (Joshua 7:15). Such crimes were punished by stoning or being excommunicated from the nation (Numbers 15:30-31; cf., 24:10-23). The atoning blood on the altar gave to these

offenders the means of forgiveness, but they had to appeal directly to God for mercy. David, who was guilty of adultery and murder, found pardon in this manner, though only after bitter tears and agonizing supplication (2 Samuel 12:13; cf., Psalm 51).[5]

But whatever the sin—whether it was unintentional or high-handed—it could only be removed by the conscious act of the one who was defiled. A genuine spirit of repentance had to accompany the sacrifice.[6] Renouncing all human merit, the person had to turn from the sin and cast himself completely upon the mercy of God.

This is expressed in the prayer offered by the sinner in most private sacrifices. As the guilty person laid hands on the head of his substitute, he repeated: "O Jehovah, I have sinned. I have done perversely, I have rebelled. I have committed [naming the specific sin]. But I return in repentance, and let this be for my atonement."[7] A similar prayer was offered by the priest when making sacrifice for the whole congregation.

The spirit of this confession was typified in the killing of the sin-laden animal. Most of the blood was applied to the brazen altar, though in some sacrifices a portion would be sprinkled before the veil in the Holy Place and also rubbed upon the horns of the altar of incense. After the blood was disposed of, the fat part of the sacrificial animal was burned on the altar, and the remainder of the flesh either eaten in the sanctuary by the officiating priest or burned outside the camp.

The whole rite was designed to show how sin could be removed. Yet, in a deeper sense, those sins that most needed cleansing were beyond the scope of the Old Testament offerings. A sacrifice greater than any provided in the Law was therefore envisioned. Not until Christ sacrificed Himself was a full sin offering provided. How wonderful to know that in

Him we have an offering in which the blood goes deeper than the stain of any sin, and that He will save unto the uttermost all that come unto God through Him (Hebrews 7:25).

> Oh, now I see the crimson wave,
> The fountain deep and wide;
> Jesus, my Lord, mighty to save,
> Points to His wounded side.
>
> I see the new creation rise,
> I hear the speaking blood;
> It speaks! polluted nature dies—
> Sinks 'neath the crimson flood.
>
> PHOEBE PALMER

Note the sin and trespass offerings described in Leviticus 4:1-21 and 5:1-13.

Numbers 15:27-31 (ASV, RSV) speaks of the sins of ignorance and the presumptuous sins or the sins of the high hand. What is the difference? Why do you think that the laws made this distinction?

What is our sin offering today? 1 Peter 2:24.

BLOOD AND FIRE

Burnt offerings were another type of blood sacrifice. This offering derived its name from a word meaning "to go up." A burnt offering was thus a sacrifice of which the smoke ascended to God as it was burned on the altar (Genesis 8:20; Exodus 29:38-43; Leviticus 1:1-17; 6:8-13).

The characteristic feature of the offering was that the

whole victim was consumed by fire after the blood was shed. Nothing was left over for the one who offered the sacrifice, except the skin of the slain animal. For this reason, the burnt offering is sometimes called a "whole" sacrifice (Deuteronomy 33:10; 1 Samuel 7:9; Psalm 51:19).

The outpoured blood on the altar and the burning of all the flesh expressed the complete consecration of the sacrificer, the total giving of self in trust to Jehovah. The smoke rising up to God declared a readiness for divine communion. By destroying the material substance of the sacrifice, the burnt offering also emphasized the true spiritual nature of worship.

This was the normal sacrifice of the Jew in proper covenant relationship with God, and therefore presupposed a state of purity. Hence, when other sacrifices were offered, they followed the sin offering, and preceded the peace offering, though they could be made separately. Private burnt offerings appropriately were called for at times when personal consecration needed special attention. This was also the only sacrifice in which a non-Israelite could participate (Leviticus 17:8; 22:18,25).

A yearling lamb was sacrificed as a burnt offering for the nation every morning and evening at the brazen altar, and therefore was called a "continual burnt offering" (Exodus 29:42). On feast days larger numbers of animals were slain accompanied by other offerings (Numbers 15:3-16). The constant repetition of the sacrifices, and the multitude of offerings on special occasions, were unmistakable reminders of the attitude that we must always have toward God.

When this rite was incorporated into the Mosaic sacrificial system, it would appear that God Himself consumed the offering by fire (Leviticus 9:24), a phenomenon that was repeated on several significant occasions thereafter (1 Chronicles 21:26; 2 Chronicles 7:1; cf., 1 Kings 18:38).

Only that fire which burned on the altar of sacrifice could be taken by the priests into the Holy Place to offer up incense before the veil (Exodus 30:9). To treat this principle lightly by getting fire from some other source, as did Nadab and Abihu, was punished by death (Leviticus 10:1-2; Numbers 3:4).

In burnt sacrifice, fire, the symbol of God's refining judgment, and blood, the symbol of man's outpoured life, came together. As they met at the altar, man's gift was consumed in the flaming presence of the Holy One. The offering was purged of all sin. Nothing remained but the ashes of a life wholly given to God. In token thereof the smoke went up as a "sweet savour" unto the Lord (Genesis 8:21; Leviticus 1:9; 4:31).

Jesus has given Himself for us as "an offering and a sacrifice to God for a sweet smelling savour" (Ephesians 5:2). His crosslike incense fills earth and heaven with the fragrance of grace. Now as joint sharers in His blood, conforming to His love, we are "unto God a sweet savour of Christ" (2 Corinthians 2:15; cf., Philippians 4:18).

> O Thou whose off'ring on the tree
> The legal off'rings all foreshadowed,
> Borrowed their whole effect from Thee,
> And drew their virtue from Thy blood.
>
> Forward they cast a faithful look
> On Thy approaching sacrifice;
> And thence their pleasing savour took,
> And rose accepted in the skies.
>
> CHARLES WESLEY

Read Exodus 29:38-46 and Leviticus 6:8-13. Reflect upon the meaning of the fire and the

consuming of the sacrifice.

With this in mind, meditate upon Isaiah 6:1-7. What is the significance of the smoke and the live coals of fire?

What does it mean when Christ is said to be "a sweet smelling savour unto God"? Ephesians 5:2.

How do we become His savour to others?

THE OFFERING OF PEACE

Following the seeking of communion through the sin offering and the readiness for communion in the burnt offering, came the celebration of communion in the peace offering (Leviticus 3:1-17). It seems to have been so called because of the heart-felt experience of those who offered the sacrifice—they were at peace with God.

Three kinds of peace offerings could be presented: praise offerings in gratitude to God (7:12-15; 22:29-30); votive offerings in which the person had bound himself by a vow (7:16-17; 22:18-23); and strictly *freewill* offerings out of a sense of devotion (7:16-17; 22:18,23). For all classes of offerings, oxen, sheep, and goats of either sex were acceptable. The offerings could be brought anytime that the need was felt (19:5). Only at Pentecost (Firstfruits) were they required (23:19-20). Usually they followed the other sacrifices, although they could be offered alone. A meal and drink offering always accompanied the sacrifice.

As in other blood sacrifices, the ritual called for the laying on of hands, slaying the substitutionary victim, and applying the blood to the altar. The point of main significance was the symbolical sharing of the offering between

God, the priest, and the person offering the sacrifice.

The fat of the animal, representing God's part, was burned on the altar (3:16-17; cf., 7:22-24). Fat, like blood, was considered as a life-giving quality and therefore belonged to God.

The breast and right shoulder of the animal were kept by the priest as his part of the sacrifice (7:28-34; 10:14-15). In this connection these portions of the offering were symbolically presented to God and then returned by God to the priest. This was done by the priest's placing his hands under those of the sacrificer, and together they moved the sacrifice up and down, right and left (7:30; 8:27; 14:24; Exodus 29:34). This "lifting up and waving" motion actually made a sign of the cross.

The remainder of the flesh belonged to the sacrificer. It could be cooked and eaten by the one making the sacrifice along with his family and friends, provided that those invited were ritually pure (Leviticus 7:15-21; Deuteronomy 12:17-18). Any part not eaten within a reasonable time had to be destroyed, for holy food could not be left to spoil.

This sacred meal typified the union that now existed between God and man, and was a pledge of their continuing friendship. The Host of heaven became the Guest of His holy people.

Indeed, it was a joyous occasion. We can understand why trumpets were blown and there was singing when the sacrifices were offered in the feast days of Israel (Numbers 10:10). The High and Holy One who inhabiteth eternity was in communion with His people. The sin that separated them was gone. With such an assurance, what could be more appropriate than "sacrifices of praise" (Jeremiah 17:26; 33:11). "Oh that men would praise the Lord for his goodness, and for his wonderful works to the children of men! And let them sacrifice the sacrifices of thanksgiving, and declare his

works with rejoicing" (Psalm 107:21-22; cf., 116:17).

This is the spirit in which we should live continually (Hebrews 13:15). Praise to the Christian is as natural as breathing. We have One who, having borne our sins away, invites us to share in a perpetual communion meal. "Behold, I stand at the door and knock; if any one hears My voice and opens the door, I will come in to him, and will dine with him, and he with Me" (Revelation 3:20, NASB).

> Lo, glad I come, and Thou, blest Lamb,
> Shalt take me to Thee as I am;
> My sinful self to Thee I give;
> Nothing but love shall I receive.
>
> Then will I tell to sinners round,
> What a dear Savior I have found;
> I'll point to Thy redeeming blood,
> And say, "Behold the way to God."

> JOHN CENNICK

Read the description of Solomon's sacrifice of peace offerings at the time of the dedicating of the temple in 1 Kings 8:54-66. Note the number of sacrifices slain. Consider why such a bloody ceremony was accompanied with such joy.

What is the reason for our sacrifice of praise today? Hebrews 13:12-15.

Note the relationship between joy and the fulness of the Holy Spirit as expressed by Paul in Ephesians 5:18-20.

Why do you think praise becomes the people of God? 1 Peter 2:9.

PERFECT LOVE

The whole validity of the sacrificial system was in the way one understood and identified with the blood. Merely going through the ceremonial rite accomplished nothing. Whether in individual or public sacrifice, it was always the intent of the heart that made the ritual valid (Psalm 51:17).

Probably the greatest error of religion is to let a ritual take the place of the reality of the Spirit that it is supposed to represent. The external ceremony helps the mind and soul grasp spiritual truth, but it is only a means to the end. Where this is not kept in mind, the form becomes idolatry, and superstition and magic take hold. This tragedy turned the ancient world into paganism, and it was a danger apparent in the religious life of Israel just as it is in our life today.

When the sacrifices were abused in Judaism, those responsible were severely reproved and punished by God. This included those who encouraged superficiality by their conduct. Nowhere is this better illustrated than in the way our Lord cleansed the temple, driving out those money changers who made a business of selling animal sacrifices. God simply will not tolerate sacrilege of anything that points to the heart of His love.

Those who entered into the holy rite of sacrifice were repeatedly told to examine their lives. A sacrifice pleasing to God had to reflect the determination to walk daily before the Lord in obedience (Psalm 40:6; Jeremiah 7:21-23). This involved an honest and compassionate relationship with one's fellowman (Isaiah 1:11-17). Hosea explained it when he said, "I desired mercy, and not sacrifice" (Hosea 6:6; cf., Amos 5:22; Micah 6:6). Jesus quoted these same words to remind the legalistic Jews that they had missed the real meaning of their religious duties (Matthew 9:13; 12:7).

Love finally is what God desires. "To love [God] with

all the heart, and with all the understanding, and with all the soul, and with all the strength, and to love his neighbor as himself, is more than all whole burnt offerings and sacrifices" (Mark 12:33; cf., Deuteronomy 30:6; 1 Samuel 15:22; Romans 13:10).

This brings sacrifice into divine perspective. In its highest sense, sacrifice is an offering of love—a demonstration of that quality of moral holiness that cannot be put in words. The blood on the altar—when the sacrificer was fully conscious of its meaning—represented a choice of complete abandon to the will of God, and thereby expressed a perfectly holy desire. As such, this desire was without sin. The sacrifice itself may have been necessary because of some transgression, but the giving of it was holy, and it was this fact—and this fact alone—that made the blood acceptable in God's sight.

Yet what is equally precious, the blood upon the altar represented God's reception of the sacrifice, and was therefore a perfect expression of His love to man. It was the token of His grace whereby God disclosed His merciful purpose to save His people. Though God was altogether holy and separate from sinners, and though His justice demanded that all uncleanness be separated from His Presence, the shed blood on His altar made known that He still loved His creation. It said that at any cost He wanted to restore union with that life which He made. Hence, the Sovereign God, perfect in all His ways, was willing—even seeking—to be reconciled in a way whereby His integrity could be preserved. The blood offered upon His altar was that way—the only way that His love could be disclosed in terms consistent with His justice and holiness. Yet it was all that He asked to make His purpose for man complete.

Behold the love of God! It's in the blood. And when you look at Calvary, you see that it is the blood of God's own Son.

Men are capable of loving a friend unto death (John 15:13). But God loved us even while we were yet enemies [sinners] (Romans 5:8). This is the quality of love that draws us to Himself and, in turn, it is what fuses our heart with His in the beauty of holiness.

> Oh! grant us Lord! to feel and own.
> The power of love divine,
> The blood that doth for sin atone,
> The grace which makes us Thine.
>
> The Spirit of adoption give:
> Teach us, with every breath,
> To sing Thy praises while we live,
> And bless Thy name in death!
>
> WILLIAM BATHURST

How does James 1:27 relate to the Old Testament sacrifices?

Read 2 Chronicles 30:16-20, which tells of some people being blessed of God even though they did not go through all the prescribed rites of cleansing. Why?

What does God really desire in sacrifice? Note 1 Samuel 15:22, Matthew 9:13, and Mark 12:33.

How do you define holiness of life?

NOTES:
1. A beautiful study of the garments worn by the priests as related to Christ is by C.W. Slemming, *These Are the Garments* (London: Marshall, Morgan & Scott). Other descriptions, less extensive, may be found in the books listed in connection with the tabernacle.

2. Nudity was never permitted in Israel, least of all in approaching the altar. This was the reason the early altar in the tabernacle did not have steps. Because of the type of robe worn by the priests, it is possible that they might have exposed their nakedness while bending over the altar (Exodus 20:26). In later times when a larger altar was constructed that required steps, exposure was prevented by the priest wearing linen pants (Exodus 28:42).

3. There are any number of good materials describing the physical features of the tabernacle and their symbolical meaning in reference to Christ. Among them are works by John Adams, *The Mosaic Tabernacle* (Edinburgh: T. & T. Clark); W. Shaw Caldecott, *The Tabernacle* (Philadelphia: The Union Press, 1904); Charles E. Fuller, *The Tabernacle in the Wilderness* (Westwood: Revell, 1955); A. Marshall, *Tabernacle Types and Teaching* (London: Pickering & Inglis); A.J. Pollock, *The Tabernacle's Typical Teaching* (London and Central Bible Truth Depot); and A.B. Simpson, *Christ in the Tabernacle* (Harrisburg: Christian Publications).

4. It was possible for an individual to offer a sin offering without killing an animal if he was too poor to afford such a sacrifice, and provided the truth of the offering applied. This was done by offering a tenth of an ephah of fine flour, without oil or frankincense, which was burned on the altar (Leviticus 5:11-13). Poverty can never be a barrier to God's pardon when the heart is repentant.

5. It should be noted that God's mercy did not cancel all the consequences of sin. David was forgiven, but his children still bore the marks of his disobedience (2 Samuel 13:11). Similarly, Ahab was forgiven for his sin, but his sons reaped its effects (1 Kings 21:29). This may seem harder for us to understand because of our excessive attention to individual rights, but it would be no problem to those in the Old Testament who recognized the solidarity of the family and race. As to why punishments for sin were so pronounced in cases of this kind, we must remember that the purpose of the Law was to show the exceeding sinfulness of sin. Cleansing the heart seems to be more important in God's sight than escaping the punishment due for sin in this life.

6. The Mishnah Tractate on the Day of Atonement reads, "If a man said: 'I will sin and repent, and sin again and repent,' he will be given no chance to repent. If he said: 'I will sin and the Day of Atonement will effect atonement,' then the day of Atonement effects no atonement." *The Mishnah*, Yoma, VIII, 8, trans. by Herbert Danby (London: Oxford, 1933), p. 172. The date of this prayer is uncertain but it probably goes back to Old Testament times.

7. Quoted in Edersheim, *The Temple*, p. 88. Prayers offered by the priests for the people may be found in *The Mishnah*, Yoma, III, 8; IV, 4, pp. 165, 166.

O for a heart to praise my God!
 A heart from sin set free;
A heart that always feels Thy blood,
 So freely spilt for me;

A heart resign'd, submissive, meek,
 My great Redeemer's throne;
Where only Christ is heard to speak,
 Where Jesus reigns alone,

A humble, lowly, contrite heart,
 Believing, true, and clean,
Which neither life nor death can part
 From Him that dwells within;

A heart in every thought renewed,
 And full of love divine,
Perfect, and right, and pure, and good,
 A copy, Lord, of Thine!

Thy nature, gracious Lord, impart,
 Come quickly from above;
Write Thy new name upon my heart,
 Thy new, best name of Love.

<div align="right">CHARLES WESLEY</div>

THESE ARE THEY WHICH
CAME OUT OF GREAT TRIBULATION,
AND HAVE WASHED THEIR ROBES,
AND MADE THEM WHITE
IN THE BLOOD OF THE LAMB.
REVELATION 7:14

3
The Paschal Lamb

The most memorable and oldest of the sacrificial feasts of
Israel was the Passover. Vividly dramatized in the ritual was
God's way of deliverance out of bondage into glorious free-
dom. Its imagery is still reflected in Christian communion.
How it all centers in the blood of Calvary's Lamb is the object
of our present study.

THE FIRST PASSOVER

It goes back to the days of Israel's slavery in Egypt. The
children of Israel had been under the lash of cruel taskmas-
ters for many years. At last they cried to God for help, and the

Lord heard their groanings (Exodus 2:23-25). In remembrance of His covenant with Abraham, God promised to redeem His people "with an outstretched arm" and to bring them into their own land (Exodus 6:2-9).

Moses was raised up to lead the people, but the pharaoh would not let them go. When plagues came upon the land, still the pagan ruler remained obstinate. Finally, God said that the firstborn son of every family would die. Only those sons behind the blood-sprinkled door would be saved.

The way of deliverance was portrayed so clearly that no one could ever mistake its meaning (Exodus 12). Each household in Israel was commanded on the tenth day of the month to choose a lamb "without blemish," a male of the first year. If the family was small, they could join with a neighbor in the observance. The animal was to be kept for four days where it could be watched to see that it was healthy, and also, perhaps to remind the household of what momentous event would soon transpire. On the fourteenth day of the month, the head of the house was to slay the lamb in the evening, then sprinkle with hyssop the blood on the two doorposts and lintel of the house. This accomplished, they were all to go inside, through the blood-marked door, and remain there until morning. No harm could come to them hidden behind the blood.

The flesh of the lamb was roasted and eaten around the family table, indicative of the intercommunion that they shared with God. Unleavened bread and bitter herbs, symbolizing the haste in their deliverance and the bitter suffering of their bondage, also were part of the meal. It was to be eaten quickly while they were fully clothed with sandals on their feet and a staff in hand. For they were soon to move out on their journey to the Promised Land. Any food left over in the morning was to be burned.

While they were observing this holy feast, the angel of

God passed over, and the first born of every Egyptian family was slain. Pharaoh arose in the night—he and all his subjects—and there was a wailing throughout the land. Moses and Aaron were summoned before the king. They were told to take their people and leave the country.

The Israelites began their exodus immediately. With their flocks and herds, gifts of gold and silver from their taskmasters, and the dough of their unleavened bread, they started their journey. Though the king soon changed his mind and pursued the Israelites to the sea, God laid bare His mighty arm to hold back the waters while His people passed over on dry land. When all were safe on the other shore, the waters returned and covered the pursuing enemy. God's people were free at last.

> Would you be free from the burden of sin?
> There's pow'r in the blood, pow'r in the blood;
> Would you o'er evil a victory to win?
> There's wonderful pow'r in the blood.
> There is pow'r, pow'r, wonder-working pow'r,
> In the blood of the Lamb,
> There is pow'r, pow'r, wonder-working pow'r,
> In the precious blood of the Lamb.

L.E. JONES

Read carefully Exodus 12. Note how the picture of Christ as the Lamb of God stands out in this first Passover. His perfection (v. 5; cf., 1 Peter 1:19); His entry into the city of Jerusalem four days before the Passover (vs. 3,6); His death toward the evening of the day (v. 6); and His sacrifice to represent the whole

household of believers (v. 46; cf., John 19:33,36).

Observe, too, how we receive the benefit of His sacrifice by faith (vs. 7,22); we live by feeding on His sacrifice (v. 8); we must accept all of Christ, His suffering as well as His joy (v. 9); we should remember the bitterness from which Christ has saved us, and be grateful (v. 8); we must forsake the old world of sin (v. 11; cf., Hebrews 13:13-14); we must not mix our life with hypocrisy (vs. 18-20); and we should always give a reason for our faith (vs. 26-27).

On the basis of these and other analogies, how would you explain the truth of Christ offering His life for us?

THE PASSOVER FEAST

In remembrance of this deliverance, the Israelites were instructed to observe thereafter a Passover feast each year when they entered the Promised Land (Exodus 12:25; 13:5). As "the beginning of months," it marked the birth of the sacred year for the Jews (12:2), and became the most important of all Jewish festivals.[1] Since it preceded the institution of the Levitical system of sacrifices, it does not properly belong to any one class of offering, though it incorporates ingredients of them all (Exodus 23:15; 34:18,25; Deuteronomy 16:1-8; Leviticus 23:5-8; Numbers 28:16-25; Ezekiel 45:21-24). Like the Melchizedek priesthood, the Passover has a uniqueness all its own.

The date of the Passover was determined by the first full moon after the spring equinox. It was followed by the Feast

of Unleavened Bread, which lasted for seven days (Exodus 13: 3-10; Leviticus 23:4-8). So closely were the two associated that before long they were regarded as one (Ezekiel 45:21; Matthew 26:17; Mark 14:12; Luke 22:1). Soon, too, the animal was not killed before each dwelling house, but rather was taken to a central place where all the men gathered for the occasion (Exodus 34:18-20; Deuteronomy 16:2, 16-17; cf., Luke 2:41). Other adaptations of the ritual were made as the years passed, but the basic meaning of the feast remained unchanged.[2]

By the time the temple was built, hundreds of thousands of rejoicing people gathered in the holy city for the great feast. Something of the magnitude of the number is indicated by a census taken by the high priest near the time of Christ when it was reported that 256,500 lambs were slain during the ceremonies.[3]

On the afternoon before the evening of the Passover meal, the lambs were killed in the temple, and the blood of each sacrifice was offered to God on the altar. The codified law of the Jews, called the *Pesahim,* describes how it was done.[4] Priests stood in two rows before the altar, each priest holding a silver or gold basin. The basin was pointed at the bottom so that the vessel could not be set down and the blood congeal. When the Israelite cut the throat of his lamb, the priest caught the blood in the basin, then passed the basin to his fellow, and to the next, each receiving a full basin and returning an empty one. The priest nearest the altar threw the blood in one action against the base. The blood flowed into drains at one end of the altar where it disappeared below the temple.

While this was in progress, the people were led in hymns of praise by the Levites. The song, called the *Hallel,* comprised Psalms 113-118. Every first line of a Psalm was repeated by the people, while to each of the others they

responded by saying, "Hallelujah" or "Praise ye the Lord."

Picture the vast throng of worshipers, the bleating of the frightened animals waiting to be sacrificed, the flash of the knife, the spurting blood, the priests in their immaculate white robes quickly passing the bloodstained bowls, the splash of the blood on the altar, the blood streaming over the altar, spilling upon the marble pavement of the temple floor, the reek of blood in the air—all this going on while the choirs and the people sang in unison the praises of God. If they could have only known the full meaning of this scene!

> The paschal sacrifice,
> And blood-besprinkled door,—
> Seen with enlightened eyes,
> And once applied with power,—
> Would teach the need of other blood
> To reconcile the world to God.
>
> WILLIAM COWPER

Read the account of the observance of the Passover in 2 Chronicles 30:13-27, 35:1-20, and Ezra 6:19-22. What strikes you about the attitude of the people on these occasions?
How do you think that the sight of the blood would have impressed you? What does this service say to you about Christ?

LED TO THE SLAUGHTER

During the eating of the Passover meal, the occasion for the sacrifice was explained by the head of each household (Exo-

dus 12:27; 13:3-10). It was a time for reflection upon the Lord's goodness and mercy in bringing His people out of bondage. But in a more meaningful way, it filled their hearts with anticipation of a final deliverance when God's Anointed One would redeem Israel from all their troubles.

As the trials of Israel increased, so did the hope of their coming Redeemer. After all, God had brought them out of suffering before; He could do it again. Not surprisingly then, so many of the messianic promises called to mind the Passover experience (see Jeremiah 23:5-8; 31:7-9; Isaiah 24:21-23; 25:6-9; 40:3-11; 43:1-3; 63:11-14). They spoke of a mighty King who, as of old, would stretch forth His arm to save His people. His coming as a suffering servant, like a sheep led to the sacrifice, was also a part of the prophecy. Few, however, were prepared to understand this aspect of it.

Many times Jesus as a boy must have heard Joseph recount the Passover story. We can only imagine what must have been on His mind as He thought about its significance in reference to His own life. How He must have meditated upon the sight of the blood of the Paschal lambs, remembering the words of Isaiah:

> All of us like sheep have gone astray,
> Each of us has turned to his own way;
> But the Lord has caused the iniquity of us all
> To fall on Him.
>
> He was oppressed and He was afflicted,
> Yet He did not open His mouth;
> Like a lamb that is led to slaughter, . . .
>
> Therefore, I will allot Him a portion with the great,
> And He will divide the booty with the strong;
> Because He poured out Himself to death.

ISAIAH 53:6-7,12 NASB

That Jesus thought deeply about the meaning of the Passover is evidenced by His conversation with the learned doctors in the temple at the age of twelve. Those that heard Him were amazed at His understanding. Even at this early time, He seemed keenly aware that He was about His Father's business (Luke 2:41-50).

At the beginning of His public ministry He was identified by the prophet John as "the Lamb of God, that taketh away the sin of the world" (John 1:29,36). This introduction could be immediately associated by men with the Passover sacrifice and promised deliverance.[5]

He interpreted His own mission in terms of this expectation. As He put it:

The Spirit of the Lord is upon Me,
Because He anointed Me to preach the gospel to the poor.
He hath sent Me to proclaim release to the captives,
And recovery of sight to the blind,
To set free those who are downtrodden,
To proclaim the favorable year of the Lord.

LUKE 4:18-19 NASB; cf., ISAIAH 61:1-2

This is the gospel of deliverance, of true freedom, of restoration. Not only will He bring glad tidings, but He will be the Lamb whose blood makes it possible.

As the time for His sacrifice drew near, Jesus went with His disciples to keep the Passover. They would scarcely have been noticed in the crowds of pilgrims making their way into the Holy City. Before them loomed the massive temple, glistening in its white marble and gold, the smoke of the altar of burnt-offering ascending to God. Its sight filled the throngs of people with gladness and pride. The sound of festivity could be heard through the streets. Jesus, too,

shared their joy, but it was not the superficial emotion of the multitudes. In His heart of love there were deeper thoughts. As He looked out over the city, His eyes filled with tears. He saw something that others did not notice. There in the distance beyond the splendor of Herod's temple was a lonely hilltop called Calvary.

> Lo! He comes, a victim willing,
> All His Father's will fulfilling;
> He will, through His precious blood,
> All things once again make good,
> Pain and shame of death sustaining,
> What was lost with joy regaining;
> Hallelujah! Hallelujah!
>
> J.A. FREYLINGHAUSEN

Read Isaiah 53 again. Compare this prophecy with the statement of John 1:29 and 36.
How did Jesus look upon His sacrificial death? Was it accidental or was it His own deliberate purpose? John 10:17-18; Luke 23:37.

THE LAST SUPPER

In keeping with the Jewish custom, Jesus instructed His disciples to make preparation for the Passover feast. They secured a large upper room in the city, and took care of the other necessary arrangements, including the purchase of a lamb. "And when the hour was come," Jesus sat down at the table with the twelve (Luke 22:14).[6]

The Master told the disciples of His great desire to eat

this Passover with them. It would be His last "until it be fulfilled in the kingdom of God" (Luke 22:16). Then He took the cup of blood (red wine), gave thanks, and said, "Take this, and divide it among yourselves" (Luke 22:17).

Probably when selecting their places at the table a contention had developed among the disciples as to which one would be the greatest. Jesus now takes the occasion to teach them that greatness is measured in selfless service to others. To impress this lesson upon them, He proceeded to wash their feet—a courtesy that had been neglected upon entering the room because the disciples were intent upon their own distinction.

This service having been completed, the roasted Paschal lamb was brought in with the other portions of the meal.[7] As they ate it, Jesus told His disciples that one of them would betray Him. Then He handed the sop of bitter herbs to Judas, who thereafter went out into the night.

Following the drinking of a second cup, Jesus as the head of the house, explained the meaning of the Passover. Doubtless He more fully interpreted the event in terms of His own mission soon to be climaxed at the cross. Though probably startled by these remarks, the group joined in singing the first part of the *Hallel,* Psalms 113 and 114: "Praise ye the Lord. Praise, O ye servants of the Lord, praise the name of the Lord. Blessed be the name of the Lord from this time forth and for evermore."

As the last refrain died away, Jesus took the unleavened bread, blessed it, broke it, and gave it to His disciples, saying: "Take, eat; this is My body" (Matthew 26:26, NASB). Then He took the third cup, called "the cup of blessing" (1 Corinthians 10:16), gave thanks, and handed it to them, saying, "This is My blood of the covenant which is *to be* shed on behalf of many for forgiveness of sins" (Matthew 26:26-28, NASB; cf., Mark 14:22-24; Luke 22:19-20). With these

words, Jesus introduced a new Passover. Perhaps at this time He gave them His farewell discourse, concluding with the High Priestly prayer (John, chapters 14-17).

The Passover meal ends by all joining in singing the second part of the *Hallel* (Psalms 115-118). It must have been a moving experience. Picture Jesus leading the little company through the Psalms:

Not to us, O Lord, not to us,
But to Thy name give glory
Because of Thy lovingkindness, because of Thy truth. . . .
I shall lift up the cup of salvation,
And call upon the name of the Lord. . . .
O Lord, surely I am Thy servant. . . .
To Thee I shall offer a sacrifice of thanksgiving. . . .
Praise the Lord!

PSALMS 115-116, NASB

Can you see Jesus with eyes lifted toward the heaven, tears running down His face, singing,

This is the day which the Lord has made;
Let us rejoice and be glad in it. . . .
Bind the festival sacrifice with cords to the horns of the altar.
Thou art my God, and I give thanks to Thee;
Thou art my God, I extol Thee.
Give thanks to the Lord, for He is good;
For His lovingkindness is everlasting."

PSALM 118:24,27-29, NASB

And when they had sung this ancient hymn, they went out to the Mount of Olives (Luke 22:39; Matthew 26:30;

Mark 14:26; John 18:1). The time of the great sacrifice had arrived. Jesus rejoiced in it. This was the hour for which He was born.

> Go forth in spirit go
> To Calvary's Holy Mount;
> See there thy Friend between two thieves,
> Suffering on thy account.

> His blood thy cause will plead.
> Thy plaintive cry He'll hear,
> Look with an eye of pity down,
> And grant thee all thy prayer.

JOHN GRAMBALD

Read an account of the Lord's last Passover supper with His disciples in Matthew 26:17-35 or John 13:1-38.

Sing the *Hallel* in Psalms 113-118. Note its appropriateness in the light of the sacrifice of Christ.

Compare Psalm 118:24 with John 17:1. What is the significance of this *day* or *hour?* Why would Jesus rejoice in it?

THE RENT VEIL

The sun was beginning to sink on the horizon, casting long shadows across the Mount. An assorted crowd of people stood looking up at the center cross. On it hung the bleeding body of the Son of God. The blood still oozed from His pierced hands and feet, slowly streaming down the rough-

hewn altar forming a red pool at its base.

For three hours He had been hanging there, "despised and rejected of men," numbered with the transgressors who hung on either side (Isaiah 53:3,12). "We did esteem him stricken, smitten of God, and afflicted" (Isaiah 53:4). Only a few times had He spoken, then very briefly, His voice almost lost amid the curses and jeers of His tormentors. But as His breathing came harder, His body convulsing with pain, He cried with a loud voice, "Father, into Thy hands I commit My spirit." (Luke 23:46, NASB).

Meanwhile back at the temple, the Passover service was well underway. Thousands of men with their lambs slowly moved toward the place where death was inflicted upon the helpless victims. The priests worked feverishly passing the blood-filled bowls to the great altar while the Levites solemnly led the people in hymns of praise. They were quite unaware that beyond the city gates the offering of God's own Lamb would soon make all their sacrifices needless.

Some of the blood of the evening sacrifice had earlier been taken inside the Holy Place and sprinkled before the veil.[8] This finely woven fabric of blue, purple, and scarlet, embroidered with golden cherubim, was hung between the altar of incense and the Holy of Holies. It hid from view the inner chamber of God's dwelling place. The priests who served the altar might come this far, but no farther. The High Priest alone could enter beyond the veil on the Day of Atonement, and then only to pour the blood of the sacrifice upon the Mercy Seat. The veil stood as a silent reminder that the day of full access was still in the future.

At the moment Jesus died on the cross, some of the priests in the Holy Place were probably performing their usual duties before the veil. Suddenly the earth started to quake; the foundations of the building shook, "and the sun was darkened, and the veil of the temple was rent in the

midst" (Luke 23:45). In one shattering moment the separating curtain was ripped from top to bottom. The barrier to the Holy of Holies fell in two limp heaps to the marble floor.

It must have been a traumatic experience for the priests. No human hand could have torn the veil. Clearly it was an act of God. One can only imagine the dismay of those who now could see unveiled the very Mercy Seat of the Almighty.

Yet it was not strange to those who knelt at the cross. The veil was a visible symbol of our Lord's body. For centuries blood had been sprinkled before it, even though the meticulously performed ritual could never grant access within. Not until the body of Christ was rent and His blood offered could a "new and living way" be opened to God through the veil, that is, His flesh (Hebrews 10:19-22).

The rent veil in the temple witnesses to the finished sacrifice at Calvary. The old ceremonial way of approaching God is ended. No longer is the offering of some animal needed as a substitute, for the true Lamb of God has taken away the sins of the world.

> Paschal Lamb, by God appointed,
> All our sins on Thee were laid;
> By almighty love anointed,
> Thou hast full atonement made:
> All Thy people are forgiven,
> Through the virtue of Thy blood;
> Opened is the gate of heaven;
> Peace is made 'twixt man and God.
>
> JOHN BAKEWELL

Picture in your mind again the suffering and death of our Lord. Meditate upon Luke 23:32-46.

Compare the sacrifice in the temple with that at
Calvary. What was the significance of the veil
being rent in twain? Hebrews 10:19-22.

NEW TESTAMENT COMMUNION

Christ's sacrifice is now our Passover. In remembrance of
this fact, we continue to observe a meal together as Jesus did
with His disciples. Our practice reflects the same principle of
sacrifice as in the Old Testament and embraces some of the
same customs, but it brings out more the spiritual reality of
the old material forms. Under the old system almost every
detail of the observance was specified. But the New Testa-
ment is not concerned with the ceremonial exactness of the
ordinance. What is important is that the supper, however
conducted, brings to mind the eternal significance of our
Lord's offering of Himself for us. It is a service of remem-
brance. The substance of bread and wine speak of Christ's
broken body and poured-out blood on the cross. Every time
we partake of these elements we "proclaim the Lord's death
until He comes" (1 Corinthians 11:26, NASB).

Eating and drinking the physical symbols of His love
show the living union that believers have in Him. What
Christ gives to us through His sacrifice is the food of our soul.
By taking internally these physical emblems of His spiritual
strength and conquest, we demonstrate how we live in Him.

The feast around the family table reflects the sweet
fellowship that we have in the church. Discord and self-
seeking are gone. "The cup of blessing which we bless, is it
not a communion of the blood of Christ? The bread which we
break, is it not a communion of the body of Christ? Seeing
that we, who are many, are one bread, one body: for we all
partake of the one bread" (1 Corinthians 10:16-17, ASV). But

let us never forget that it is the blood of Christ that brings us together, and our unity is at the altar of His sacrifice (10:18).

In the first years of the early church, the Lord's supper was observed daily in connection with a simple meal in their homes. Christians in communion with their Lord felt themselves to be members of one family of God. All distinctions of rank, wealth, culture, and race were forgotten. As the church increased in size, this simple feast of love became more difficult, and led to some abuses (11:33-34). Perhaps this was why gradually the communion meal became more of a formal sacrament, though some Christians still follow the original custom.

The communion meal is a thanksgiving celebration for the victory that we have in Christ. Like the ancient Israelites, we rejoice in the assurance that we have passed from bondage into freedom, from darkness into light, from death into life. Even more, it points to the day when we shall eat and drink at our Lord's table in the heavenly Kingdom (Luke 22:28-30; cf., Matthew 8:11; Luke 13:28-29; Isaiah 25:6). The Christian Pasch now is but the foretaste of that which is to come. As such, it is the announcement, the promise, and the anticipation of Christ's triumphant coming again (1 Corinthians 11:26).

Naturally, the observance of this holy rite calls for personal self-examination. "Whosoever shall eat the bread or drink the cup of the Lord in an unworthy manner, shall be guilty of the body and the blood of the Lord" (11:27, ASV). For this reason we should honestly judge ourselves before coming to the Lord's supper. Anything that is not right with God or our fellow man should be confessed. At the table of our Lord we must be free to love without condemnation.

It was the custom in Israel (and still is among orthodox Jews), for the head of the house to make sure that no leaven, representing the old life of bondage, was somewhere hidden

in the place where the Passover was to be eaten (Deuteronomy 16:3). Accordingly, before the meal a careful search was made of the premises with a lighted candle, and any leavened bread found had to be destroyed. Nothing that was on the other side of the blood could be allowed to contaminate this feast.

We are told, too, to "purge out" of our lives anything characteristic of the old leaven and to be a "new lump" of unleavened bread as we partake of His Holy Communion. Let us be sure that it is done. "For Christ our Passover also has been sacrificed" (1 Corinthians 5:6-7, NASB).

> Jesus, Master, whose I am,
> Purchased Thine alone to be,
> By Thy blood, O spotless Lamb,
> Shed so willingly for me,
> Let my heart be all Thine own,
> Let me live to Thee alone.

FRANCES R. HAVERGAL

Read the instructions of Paul pertaining to the Lord's supper in 1 Corinthians 10:16-18 and 11:23-34. How does this service speak of Christ's blood?

What is the meaning of the old leaven? Why must we search our hearts in sincerity and truth before taking Holy Communion? 1 Corinthians 5:7-8.

If you have reference to your church ritual, read the prayers in connection with the Communion service. Do these petitions truly express the intent of your heart?

THE LAMB IN HEAVEN

The language and symbolism of the Passover celebration run through the whole book of Revelation. In fact, the experience of heaven reflects continuous holy communion.

Jesus is pictured twenty-nine times in this book as the Lamb of God. In this figure reminiscent of the ancient sacrifice, He reigns (Revelation 5:8,13; 7:9-10,17; 14:1,10); He judges (13:8; 21:27); He reveals (6:1); He leads (14:4); He sends apostles (21:14); He makes war (6:16; 17:14); He overcomes (12:11; 14:10; 17:14; 21:11); He saves (13:8; 21:27); He gives light (21:23). The realization of what this means continually invokes the praise of His saints as they sing, "Worthy is the Lamb that was slain to receive power, and riches, and wisdom, and might, and honour, and glory, and blessing" (5:12).

The Lamb is the mighty Savior who will finally deliver His people from the suffering and struggle of this present age. Out of their afflictions John sees a new exodus with a great multitude coming before the Lamb, singing, "Salvation to our God which sitteth upon the throne, and unto the Lamb" (7:10). When asked who these people are, the answer is given: "These are they that came out of great tribulation, and have washed their robes, and made them white in the blood of the Lamb" (7:14).

The picture of their new habitation resembles that described by Isaiah when he visualizes the final Passover of God's chosen people. Those that have been bound by the evil forces of this world are told to "go forth" and claim their inheritance. God is their Redeemer, so they need have no fear. "They will not hunger or thirst, Neither will the scorching heat or sun strike them down; For He who has compassion on them will lead them, And will guide them to springs of water" (Isaiah 49:10, NASB). Though the way is hard and

surrounded with many dangers, "the Lamb which is in the midst of the throne shall be their shepherd, and shall guide them unto fountains of waters of life: and God shall wipe away every tear from their eyes" (Revelation 7:16-17).

When the redeemed of the earth reach their destination, their song echoes the shouts of Israel after crossing the Red Sea (Exodus 15:1-19).

> They sing the song of Moses the servant of God, and the song of the Lamb, saying, Great and marvellous are Thy works, Lord God Almighty; just and true are thy ways, thou King of saints. Who shall not fear thee, O Lord, and glorify thy name? for thou only art holy; for all nations shall come and worship before thee; for thy judgments are made manifest.
>
> REVELATION 15:3-4

The church is God's glorious achievement of grace. Fully aware of this fact, the saints cease not to sing praise to their King, the Lord God omnipotent who reigneth. It reaches a climax of joy at the marriage supper of the Lamb. The picture is one of a great feast in which the bride, the blood-washed church victorious over all, is presented in formal wedlock to the Lord (19:9).

In that glorious day we shall see His face (22:4). Knowledge will be direct. There will be no need for any forms of worship, "for the Lord God the Almighty, and the Lamb, are the temple of it. And the city has no need of the sun, neither of the moon, to shine in it: for the glory of God did lighten it, and the Lamb is the light thereof" (21:22-23). There, around

the throne of God and of the Lamb, we shall reign with Him from glory to glory from *Hallelujah to Hallelujah,* forever and ever (22:1-5).

> And when I enter in Thy joys,
> With Thee Thy kingdom sharing,
> Thyself my robe of triumph, Lord,
> Thy blood my right declaring,
> Shall place upon my head the crowns,
> Shall lead me to the Father's throne,
> And raiment fit provide me;
> Till I, by Him to Thee betrothed,
> By Thee in bridal costume clothed,
> Stand as a bride beside Thee!

PAUL GERHARDT

Read the songs of heaven in Revelation 5:6-14, 7:9-17, 14:1-5, 15:2-3, and 19:1-6. Observe how many times reference is made to the Lamb. Why do you think that the redeemed like to speak of Christ in this way?

What is the idea of union with Christ that is conveyed in the figure of marriage?

How can the Lamb be the Light of Heaven? Does this suggest to you something about the basic character of spiritual perception? Revelation 21:22-24.

NOTES:
1. Other great Jewish feasts were the Feast of Weeks and the Feast of Tabernacles. According to Levitical law, all male Jews were required

to attend these public festivals (Exodus 23:14-17; Deuteronomy 16:16)

2. There is some difference among Old Testament scholars in the way the Passover was observed, especially as it developed in later Judaism. Our purpose in this study is not served by detailed descriptions of these points of view. However, if this is of interest, the subject is treated in depth by Philip Goodman, *The Passover Anthology* (Philadelphia: The Jewish Publication Society of America, 1961); and J.B. Segal, *The Hebrew Passover* (London: Oxford University Press, 1963). Also the authorities cited in reference to Jewish sacrifice discuss the subject, though in less detail.

3. *The Works of Flavius Josephus* (Philadelphia: Henry T. Coates, *Wars of the Jews*, VI, 9, 3, p. 832.) These figures may not be reliable though reported from official documents. However, even allowing for exaggerations, the number was certainly immense.

4. Danby, *The Mishnah*, pp. 136-151.

5. Most Bible students favor this association, though the expression may have a different reference. The application might be to "the Lamb that is led to the slaughter" envisioned by Isaiah (53:7); "The gentle lamb" described by Jeremiah (11:19, ASV, RSV); the Lamb promised to Abraham (Genesis 22:8); the daily sacrifices in the temple; the triumphant Lamb of the Apocalypse, among others. However interpreted, its general reference to sacrifice appears obvious. Leon Morris believes that the term fulfills all that is foreshadowed in all the sacrifices of Israel. "That the Lamb is said to be 'of God' would seem, in accordance with the view, to indicate that the perfect sacrifice is the one which God Himself provides." (Morris, *The Apostolic Preaching*, p. 143.)

6. There is some question about the time and nature of this Passover meal observed by Jesus. If it was the regular feast according to the official Jewish calendar, it would have come on a Thursday evening, which was the beginning of their Friday. By this reckoning, the death of Christ came on the day after the slaughter of the lambs in the temple, or the second day of the eight-day Feast of Unleavened Bread. This whole period was considered part of the Passover celebration, and sacrifices continued to be offered during this time, so it would still be appropriate to speak of Christ dying during the Passover. A representative statement of this position is in Edersheim, *The Temple*, pp. 341-351. However, other students of the New Testament believe that the Last Supper of our Lord was eaten before the official Passover festivities began, though the meal probably followed much the same pattern as the regular Pasch. By this accounting, the crucifixion of Christ coincided with the public offerings in the temple. Reasoning favoring this view is in W.F. Farrer, *The Life of Christ* (Portland: Fountain Publications, 1964), pp.691-697. Many of the problems

respecting the accounts of this Passover have been resolved in recent studies that have established that there were two different calendars recognized at the time of Jesus, both of which enter into the Gospel records. The Synoptic writers seem to report the Passover in terms of the fixed-date priestly code (Matthew 26:17-35; Mark 14:12-31; Luke 22:7-18); whereas the Johanine account follows more the flexible official calendar of the day. Documents uncovered that pertain to the Qumron Community, as well as early patristic tradition, support the idea that Jesus kept the Passover meal in accordance with the priestly calendar of the Old Law. This would have put His supper on Tuesday night, or the beginning of their Wednesday. Yet His death on Friday came at the time prescribed by the official calendar when the Paschal sacrifices were offered in the temple. Hence, if this view is correct, Jesus gathered together both lines of the Jewish tradition and brought them to fulfillment. A complete discussion of this position is in Annie Joubert's, *The Date of the Last Supper* (Staten Island, N.Y.: Alba House, 1965).

7. Where the Gospel accounts are silent, I have drawn upon other sources to fill in details about the way a Passover meal was observed in that day. In addition to the authorities already cited, much helpful information at this point may be found in P. Grelat and J. Pierson, *The Pascal Feast in the Bible* (Baltimore: Helicon, 1965), pp. 91-107; and Philip Vollmer, *The Modern Student's Life of Christ* (New York: Revell, 1912), pp. 231-240.

8. The evening burnt offering preceded the sacrifice of the Passover lambs. On this occasion it would have been killed at 1:30 P.M. with the slaughter of the Paschal lambs beginning soon thereafter. When all the lambs were slain, then the priests inside the Holy Place burned incense and trimmed the lamps for the night.

Arise, my soul, arise;
 Shake off thy guilty fears:
The bleeding Sacrifice
 In my behalf appears:
Before the throne my Surety stands,
My name is written on His hands.

He ever lives above,
 For me to intercede;
His all-redeeming love,
 His precious blood to plead;
His blood atoned for all our race,
And sprinkles now the throne of grace.

Five bleeding wounds He bears,
 Received on Calvary;
They pour effectual prayers,
 They strongly speak for me;
"Forgive him, O forgive," they cry,
"Nor let that ransomed sinner die!"

The Father hears Him pray,
 His dear anointed One;
He cannot turn away
 The presence of His Son;
His Spirit answers to the blood,
And tells me I am born of God.

My God is reconciled,
 His pardoning voice I hear:
He owns me for His child,
 I can no longer fear;
With confidence I now draw nigh,
And, "Father, Abba, Father" cry.

CHARLES WESLEY

THIS IS THE BLOOD
OF THE TESTAMENT WHICH GOD
HATH ENJOINED UNTO YOU.
HEBREWS 9:20

4
The Blood Covenant

The close relationship between the Word and the blood comes into dramatic focus in the concept of a covenant. It is the blood that witnesses to the Word and finally seals its testimony. How this custom comes to fruition in the New Covenant of our Lord is a precious truth to which we now turn our attention.

PERSONAL INTEGRITY

Blood today is a universal symbol of loyalty unto death. This is why the color red, representing blood, is so prominent in national emblems. Whether it be seen in the red stripes of

Old Glory or in the red star of Communism, it says that those who live under this sign will give their life for that for which it stands.

Among primitive peoples this quality was dramatized by the actual shedding of blood in some kind of ceremonial testimony. For example, if two persons wanted to enter into a friendship pact, they might cut the palms of their hands so that the blood freely flowed. Then they would clasp their palms, much like we shake hands today. The intermingling of the blood bound their lives together in an undying witness of solidarity. Perhaps this custom was in the mind of the prophet when he said of God, "Behold, I have graven thee upon the palms of my hands" (Isaiah 49:16).[1]

In the same sense of covenanting, in some eastern cultures if a person wanted to impress a congregation of people with the veracity of his word, he might cut his forearm in their presence. Then lifting it up toward God, he would make his statement. As the blood ran down his arm, the symbol of his strength, it bore witness that what he said with his lips he would support with his life. Possibly this was in the thinking of Isaiah when he wrote, "The Lord hath sworn by his right hand, and by the arm of his strength" (Isaiah 62:8). The practice even today of lifting up the arm when taking an oath, as in a court of justice, may trace back to this ancient custom of swearing by one's blood.[2]

However it might be expressed, blood is inherent in the concept of a covenant.[3] The Hebrew word itself, used nearly 300 times in the Bible, probably comes from a root that means "to cut." The blood that was drawn expressed a commitment unto death and thereby witnessed to the inviolable nature of the agreement. This idea carries over into the terms "testimony" and "oath," which are sometimes used in the same sense as covenant. Also the Biblical concept of "word" reflects this obligation.

Have you ever tried to describe integrity—that quality of being completely trustworthy? Such words as faithfulness, honesty, dependability, and honor might come to mind. But if you pointed to a person whom we all knew, and could truly say, "There's an illustration. Jim is as good as his word," we would know much better what you meant. His character that we could see would make your word come alive.

In a much deeper way, that is what God did when Jesus lived and died. All the blood on Jewish altars for thousands of years pointed to Him. It proclaimed that what God said, He would also do. When Christ died, the word was clear. God's own heart was revealed. It was as though He lifted up His hand and made an oath for all heaven and earth to witness. We know that He meant what He said. We can see the blood.

> Think of this word, O guilty soul!
> Despair not: Christ can make Thee whole,
> In Him there's pardon, peace, and grace.
> A sure and blessed hiding-place.
> The covenant, confirmed by blood,
> Doth stand upon the oath of God.

JOHANN HEERMANN

In the light of your previous study, why would the blood be an appropriate seal of a covenant? How does the blood reflect the integrity of a person?

Meditate upon Isaiah 49:13-16. Look at your hands. Imagine God writing your name on the palm of His hand. Think of the blood of Christ as His writing fluid. Now clasp your hand in His. You are ready for prayer.

THE THRESHOLD

One of God's great covenants assured Abraham of an heir and a posterity that would come into a new land (Genesis 15:1-21; cf., 12:7-8; 13:14-18). To confirm the promise, Abraham was instructed to cut in half a three-year-old heifer, a female goat, and a ram. The divided animals were then to be "laid each half over against the other" (15:10), forming a bloody wall, much like two sides of a door. When the sun set, a flaming torch, representing the divine Presence, passed through the blood-saturated threshold in token of His pledge.

This covenanting rite was not uncommon among the people of that day. The blood-shedding symbolized the veracity of the persons involved, while it also indicated the fate of anyone who might break the covenant. A fearful judgment came upon the children of Israel when they did not keep the words of the covenant entered into in a similar manner (Jeremiah 34:18-20; cf., Amos 7:8-9).

Again we note in this custom the concept of an altar as an entrance into a new relationship. A covenant was something that was entered into like coming into a house. The practice of offering sacrifices at the door of their homes was a way of assuring protection to all who came within the house. Crossing the threshold bound one to the highest ethical behavior in respect to all others in the house. Of course, if a person came in some other way, he was not so obligated. That is why a thief would not come through the door of a house to rob or kill. Rather he would dig through the dirt walls to accomplish his devious task. He dared not violate the sacred trust of the threshold (Matthew 6:19-20; 24:43; John 10:1,10; Luke 12:39; cf., Exodus 22:2; Ezekiel 12:2-7). Only friends come in by the blood-consecrated door.

The place where the blood was offered was so sacred

that even on entering by the door, one was not to step on the threshold. To trample on the blood would be to show contempt for the host, and such an indignity could not be tolerated in their society. This was probably in the mind of the author of Hebrews when he spoke of the punishment that awaits those "who hath trodden under foot the Son of God, and hath counted the blood of the covenant wherewith He was sanctified an unholy thing" (Hebrews 10:29).

The solemn obligations assumed in the blood were called to mind by the practice of the Israelites writing the words of the covenant upon the doorposts of their houses (Deuteronomy 6:4-9; 11:13-21). These words were usually inscribed in parchments and enclosed in a case of metal or wood affixed to the sideposts of the entrance. It was the custom for every good Jew to touch this symbol of the covenant every time he went through the door. Putting his finger to his mouth, he would kiss it and say, "The Lord shall preserve thy going out and thy coming in from this time forth, and even for evermore" (Psalm 121:8).

Christ's blood is our covenant; His cross our threshold of eternal life. We can be sure that all who enter in are safe in the household of God's love.

> I love Thy kingdom Lord,
> The house of Thine abode,
> The Church our blest Redeemer saved
> With His own precious blood.
>
> I love Thy church, O God;
> Her walls before Thee stand,
> Dear as the apple of Thine eye,
> And graven on Thy hand.

TIMOTHY DWIGHT

> Reflect upon Genesis 15:1-21. Picture in your
> mind entering the covenant through the
> threshold of blood.
> Read Deuteronomy 29:10-13. Put yourself and
> your family into this covenant. How do you
> get there?
> Look at the door. How does it speak to you of
> Christ and the covenant? John 10:1-18.

SEALING WITH BLOOD

The blood as a seal between two covenanting parties is seen in
the Israelite circumcision of the male child. This bloody rite
became the sign of God's covenant with Abraham (Genesis
17:1-27). Those who did not receive the operation had no
part in the promise, for God said, "He has broken my cove-
nant" (17:14).

An indication of the importance of the practice is seen in
an experience of Moses shortly after leaving Jethro's home to
return to Egypt. For some reason he had neglected to cir-
cumcise his second son. When God approached him about
the matter, Moses feared for his life (Exodus 4:24). Catas-
trophe was averted only when his quick-witted wife took a
sharp stone and cut off the foreskin of her son. Flinging it at
her husband's feet, she cried, "A bridegroom of blood art
thou, because of the circumcision" (4:25-26). Regardless of
the way this difficult passage is interpreted, it would appear
that the blood of circumcision had a binding quality much
like that of the marriage vow.

The witness between Abraham and Abimelech is another
example of blood sealing a covenant. Though sacrifice is not
specifically mentioned, it is clearly implied in the setting

apart of the seven ewe lambs (Genesis 21:22-32). Likewise the covenant between Jacob and Laban is accompanied by offering a blood sacrifice followed by a communion meal (31:43-55).

The Passover deliverance, already described, illustrates the same idea. God said, "And the blood shall be to you for a token upon the houses where ye are; and when I see the blood, I will pass over you" (Exodus 12:13).

I expect that the family looked on breathlessly as the father killed the Passover lamb. Their eyes followed his movements when he dipped the hyssop branch in the blood of the lifeless sacrifice. Throbbing with excitement, they watched him sprinkle its precious substance on the threshold of their house. The warm blood speckled the doorposts and lintels like red paint. Some of it ran down the walls and splashed to the hot earth. It was the witness to them of God's presence.

Having observed the solemn event, they went inside and closed the door. Their security was now in the hands of Him who had spoken to Moses. Within the house they could no longer see the blood, but God could see it, and at its sight they were saved. It witnessed to God of their faith in His word.

The idea of being marked by the blood for deliverance again is the reference of Ezekiel when he visualized the destruction of Jerusalem (Ezekiel 9:1-11). Here a man clothed in fine linen, representative of Christ, is told "to set a mark upon the foreheads" (v. 4) of certain people. The custom of placing an identifying sign on the forehead was a common way of designating worshipers of a particular deity, a practice still followed by some religions of the East. In this case it indicated those persons who had maintained their vows to Jehovah in the face of apostasy all about them. Jerome and others following the Vulgate translation believe that the mark

was the letter *tau* in the Hebrew alphabet, which was at the time written like a cross. But whatever the nature of the sign, it did for those marked what the blood sprinkled on the doorposts did for the earlier Israelites. When the avengers, beginning at the house of God (Ezekiel 9:6; cf., 1 Peter 4:17), went through the city slaying utterly all who had worked abomination, only those faithful ones marked by the sign were spared.

This symbolic way of identifying allegiance is mentioned a number of times in the new Testament (Revelation 7:2-3; 9:4; cf., 14:1; 22:4; 2 Corinthians 1:22). Though the nature of the mark is not specified, for those that belong to Christ the identifying sign is the blood of the cross. It bears witness before heaven that our hearts are sealed in a holy covenant.

> Father, hear the blood of Jesus,
> Speaking in thine ears above!
> From Thy wrath and curse release us,
> Manifest Thy pard'ning love:
> O receive us to Thy favor,
> For His only sake receive;
> Give us to our bleeding Savior,
> Let us by His dying live!

<div align="right">CHARLES WESLEY</div>

Meditate upon Exodus 12:13. In what sense was the blood a sign to both the Israelites and to God?

Read Psalm 50:5 in several translations. Observe how the covenant is made with God by sacrifice. Why are those that make it called *faithful ones* or *saints?*

How is the seal of God related to the concept of a
covenant in blood? 2 Corinthians 1:22.

THE LAW CONFIRMED

A blood covenant carries with it sacred obligations. The
giving and receiving of the law at Sinai is one of the most
dramatic portrayals of this principle. When Moses told the
people "all the words of the Lord," the congregation an-
swered with one voice, "All the words which the Lord hath
said will we do" (Exodus 24:3). Accordingly Moses wrote the
words in a book as a permanent record of what God said.

But the testimony did not end there. The account goes
on to say that Moses "rose up early in the morning, and
builded an altar under the hill . . . And he sent young men of
the children of Israel, which offered burnt offerings, and
sacrificed peace offerings of oxen unto the Lord" (24:4-5).
These sacrifices, as has been noted, indicated their complete
consecration to God and their joy in His fellowship (no sin
offerings are mentioned, apparently because in this situation
they were not necessary). .

Then to impress the sacred bond of the agreement even
more forcibly upon the people, "Moses took half of the
blood, and put it in basons; and half of the blood he sprinkled
on the altar. And he took the book of the covenant, and read it
in the audience of the people: and they said, all that the Lord
hath said will we do, and be obedient. And Moses took the
blood, and sprinkled it on the people, and said, Behold the
blood of the covenant, which the Lord hath made with you
concerning all these words" (24:6-8). The account in Hebrews
adds that Moses also sprinkled blood on the book of the
covenant, thus bringing every aspect of the transaction under

this hallowed seal (Hebrews 9:19).

Following this formal ratification of the law, Moses, with the leading priests and seventy elders of Israel, entered into a communion meal. "And they saw God, and did eat and drink" (Exodus 24:9-11).

This whole celebration has many ingredients of a wedding ceremony in which both parties enter into a solemn exchange of vows. God, for His part, covenants to fulfill all the words written in the book, and his people promise to obey all that God says. The blood in the ceremony is like a wedding ring. It is the outward symbol of their holy wedlock.

Yet it is more than a symbol. The blood is the communication of their trust and love. It proclaims commitment in a way that words can never express. Hence the blood, not the book of the Law, is the testament that God enjoins (Hebrews 9:20). Here was the soul laid bare, the very essence of character for every eye to see.

So it is with Jesus. His blood is the wedding band. As the ancient Jews confirmed the old covenant at Sinai, we are joined to Christ in a new covenant at the cross (12:24). The blood witnesses to the unprofaned character of our love. With all that we are and hope to be we promise to love, honor, and obey. And in this covenant, death cannot part us.

> I build on this foundation—
> That Jesus and His blood
> Alone are my salvation,
> the true eternal good:
> Without Him, all that pleases
> Is valueless on earth;
> The gifts I owe to Jesus
> Alone my love are worth.
>
> PAUL GERHARDT

Read Exodus 24:1-11. Picture in your mind the scene at Sinai as nearly two million people enter into the blood covenant. Imagine how they felt when the blood was sprinkled.

Put Hebrews 9:20 in your own words. Why is the blood of the covenant commended to the people?

In what way is the blood of Christ our bond of love?

MORAL OBLIGATION

The moral obligations assumed through the blood are underscored continually through the Old Testament. Though the people are generally remiss in keeping the law and come under judgment because of their disobedience, they are never allowed to forget the demands and privileges of the covenant.

A beautiful example is Moses' message to the children of Israel after the forty years of wandering. The faithless generation had died in the wilderness, and their children are now ready to enter the Promised Land. Having recounted before them the law given to their fathers, he says, "This day the Lord thy God hath commanded thee to do these statutes and judgments: thou shalt therefore keep and do them with all thine heart, and with all thy soul" (Deuteronomy 26:16).

There follows a lengthy description of the blessings that God will bestow upon His people if they keep His covenant. If they are unfaithful, they can expect His curses (Deuteronomy chapters 27-28; cf., Exodus 19:5-6). It all rests upon the great *if*. With God there is no variableness nor shadow of turning. The only question is with man. Moses calls heaven

and earth to record that God has set before them "life and death, the blessing and the curse." Therefore, he says, "choose life, in order that you may live, you and your descendants." The summons of the covenant is to love "the Lord your God, by obeying His voice, and by holding fast to Him" (Deuteronomy 30:19-20, NASB).

As you would expect, they are instructed upon crossing the Jordan to build an altar and offer burnt offerings and peace offerings to God (27:5-8). This Joshua faithfully observes. Amid the blood sacrifices, while the smoke ascends up to God, he has all his countrymen hear the words of the law (Joshua 8:30-34). "There was not a word of all that Moses commanded, which Joshua read not before all the assembly of Israel" (Joshua 8:35, ASV).

The ethical demands of the covenant always come to the fore in times of revival. The awakening under the leadership of Ezra and Nehemiah is a good example (Nehemiah chapters 8-10). Following the joyous celebration of the Feast of the Tabernacles and its accompanying offerings of blood, the people hear recited the providences of their history. Whereupon they enter "into a curse, and into an oath, to walk in God's law, which was given by Moses the servant of God" (Nehemiah 10:29).

Of course, God knew that His people could not fulfill perfectly the moral obligations of the law. Human nature, corrupted by sin, simply cannot attain to the incorruptible nature of God's word. Though man was expected to measure his life by it and had to suffer for disobedience, the only hope for salvation was in the mercy of God. In this sense the law was like a schoolmaster bringing the children of the covenant to see the necessity for deliverance on the sovereign level of grace.

It all leads to Christ. In Him alone can the moral obligations of the law be fulfilled. Thus the blood of the covenant,

while demanding perfect obedience, ultimately called men to believe in Christ even as it assured us of His promise of grace.

> Thy grace alone, O God,
> To me can pardon speak;
> Thy power alone, O Son of God,
> Can this sore bondage break.
> No other work save Thine,
> No meaner blood will do;
> No strength, save that which is divine,
> Can bear me safely through.

> HORATIUS BONAR

To feel the personal obligation of the covenant, read Deuteronomy 30:11-20.

Why would the law involve both a blessing and a curse? Joshua 8:30-35.

Read Galatians 3:15-26. Why are we all condemned by the law? In what sense does the covenant of promise precede the giving of the law? Why is salvation ultimately received by faith in Christ, not by works of righteousness?

THE EVERLASTING COVENANT

The covenant of grace is seen in the very initiative of God giving His promise of redemption. It is a gift simply announced by His word, not because man deserves it, but because God is merciful. From the beginning, the blood of the covenant is a testimony of God's unmerited love.

The pledge first is heard in the garden of Eden following

man's disobedience. Scarcely had the creature believed Satan's lie before God declared that one day the power of the usurping king would be crushed by the seed of woman (Genesis 3:15). Adam had done nothing to merit this assurance. God just gave the promise. Then, showing His compassion, He sacrificed an innocent animal to make coats of skin to cover our shameful forebears (3:21). The bloody garments wrapped around man the certainty of divine care despite his sinfulness.

A word of blessing comes again when Noah offers up burnt sacrifices after emerging from the ark. Jehovah smelled the sweet savor and said that He would never again smite the earth by water. Man would be fruitful and multiply. What the rainbow confirmed in the sky, the blood witnessed to on the altar (8:20-9:17).

God swore in blood to raise up a chosen people through Abraham (15:18; 17:2), and the promise was repeated to his sons and to their sons. Moses was told that God would make through him a holy nation (Exodus 19:5-8; cf., Numbers 25:12-13). To David, the "everlasting covenant" was renewed, and the assurance of a coming kingdom further specified (2 Samuel 23:5).

In all these covenants progressively unfolding God's gracious design for His people, there is the anticipation of something better—not clearly disclosed—but always promised as their inheritance. Sometimes the prophets speak of it as a "new covenant" when God shall write His law "in their inward parts" (Jeremiah 31:33). This spiritual knowledge would not come through reciting the law. Rather it would be experienced in the heart, "from the least of them unto the greatest" (31:34; cf., 2 Corinthians 3:6,14; Hebrews 8:10). The old stubborn heart of stone would be taken away, and God would put a new spirit within them (Ezekiel 36:?6-38; cf., 20:34-44).

The fulfillment of this promise is seen in the Messiah, the "Branch of righteousness" growing out of David (Jeremiah 33:14-16, 20-22; cf., Ezekiel 37:21-28). Christ is visualized as "the messenger of the covenant" (Malachi 3:1). In His Person the covenant is given to the people (Isaiah 42:6), and salvation reaches to the ends of the earth (49:6).

Bound up with the promise is a future reign of blessedness when all trouble will be ended and the children of God enter their land of eternal joy: "'The mountains may be removed and the hills may shake, But My lovingkindness will not be removed from you, And My covenant of peace will not be shaken,' Says the Lord who has compassion on you" (54:10, NASB). Every desire of the spirit would be satisfied in this kingdom of God's eternal love (Ezekiel 34:25-31; 37:26-28; Isaiah 56:1-8; 61:4-11).

In this anticipation, the children of the covenant were called "prisoners of hope" (Zechariah 9:12). Though they were often oppressed because they did not keep their oath (Ezekiel 16:59), God still loved them, and remembered His merciful purposes of redemption (16:60; Luke 1:72). The blood of that covenant was assurance that someday they would be set free (Zechariah 9:11). God keeps His word.

Thus, Israel could rejoice, even in the face of adversity. Her King was coming. "He is just, and having salvation; lowly, and riding upon an ass, even upon a colt the foal of an ass . . . He shall speak peace unto the nations: and his dominion shall be from sea to sea, and from the River to the ends of the earth" (9:9-10, ASV).

> I will sing of my Redeemer,
> And His wondrous love to me;
> On the cruel cross He suffered,
> From the curse to set me free.
> Sing, oh, sing of my Redeemer,

With His blood He purchaséd me,
On the cross He sealed my pardon,
Paid the debt and made me free.

P.P. BLISS

Read the joyful messianic promise in Zechariah
9:9-11. Note the relation of Christ's coming
to the blood covenant.
Meditate upon Jeremiah 31:31-34 and Hebrews
8:8-10 and 10:16. What is the difference
between the old covenant and the new?
How is the everlasting covenant sealed in blood?
Hebrews 13:20. How do we become children
of the covenant? Acts 3:25-26; Luke 1:71-75.

THE NEW TESTAMENT

That which all symbol and rite, all inspired prophecy, all
yearning of life through the ages had anticipated came to its
glorious climax at Calvary. Jesus had said that the New
Testament would be given in His blood (Matthew 26:28;
Mark 14:23; Luke 22:20), and now the promise was fulfilled.
Not one word that He had spoken had failed.

In the New Testament the word for covenant may also
mean a last will and testament that is inoperative until after
the testator's death. It is the legal sense of the term as used in
the Roman world at the time and which is still reflected in our
law today. This idea is developed particularly in the Epistle
to the Hebrews where Christ is called the "mediator of a New
Testament," that by means of His death we might receive
"the promise of the eternal inheritance. For where a testa-

ment is, there must also of necessity be the death of the testator" (Hebrews 9:15-16; cf., 8:6; 12:24).

It is worthy of note that when the soldiers at the cross pierced the side of Jesus to make sure He was dead, there flowed out water and blood from His side (John 19:31-37).[4] These elements, with the Holy Spirit, speak of the perfected life and work of our Lord. Very likely this is the reference of John when he wrote that the Spirit, the water, and the blood bear witness on the earth (1 John 5:8).[5]

Again we are reminded of the relationship between the Spirit and the blood. Together they verify the living experience of the new covenant in our life. "The one who believes in the Son of God has the witness in himself; the one who does not believe God has made Him a liar, because he has not believed in the witness that God has borne concerning His Son. And the witness is this, that God has given us eternal life, and this life is in His Son" (1 John 5:10-11, NASB).

The blood also bears witness in heaven. For Christ "through his own blood" has entered the sanctuary not made with hands "to appear before the face of God for us" (Hebrews 9:12,24, ASV). In this "greater and more perfect tabernacle" (9:11), His bloodstained body has borne witness to His completed mission, and by His Presence "the heavenly things themselves" have been purified (9:23).[6]

Here the blood takes on its highest spiritual meaning. We are left utterly breathless in wonder. Though the details are not explained, we know that the death of our Lord has dimensions reaching into heaven. There, in some way beyond our present understanding, we will see the blood of Christ. For like the resurrected body of our Lord, His blood remains incorruptible (cf. 1 Peter 1:18-19; Acts 2:27), and in its true spiritual substance, will always appear in heaven as God's eternal covenant.

It is there now before the throne. It will be there

forever—the remembrance of His unspeakable gift and the revelation of His unchanging Word.

> Jesus, Thy blood and righteousness
> My beauty are, my glorious dress;
> Midst flaming worlds, in these arrayed,
> With joy shall I lift up my head.
>
> Lord, I believe Thy precious blood
> Which at the mercy-seat of God
> For ever doth for sinners plead,
> For me, e'en for my soul was shed.

N.L. VAN ZINZENDORF
TRANSLATED BY JOHN WESLEY

How is Jesus the Mediator of a new covenant? Hebrews 12:24.

Why does the Spirit witness along with the blood and the water? How does this witness support your own? 1 John 5:10-13.

Imagine the blood as a witness in heaven. What does the concept of the blood add to your understanding of heaven? Hebrews 9:22-24.

NOTES:

1. Evidence supporting this idea is recorded by Trumbull in *The Blood Covenant*, pp. 234-236. Among many nations, including the Medes, Lydians, Armenians, Arabs, and Synthians, parties to a treaty often would draw blood from their veins, mix it in some container, then drink the contents. It was a way of publicly showing that the two parties, and sometimes their relatives, were henceforth to be regarded as blood kin. See Mischa Titiev, *Cultural Anthropology* (New York: Henry Holt & Co., 1959), p. 297. However, this custom of drinking was not observed in Israel.

2. See Trumbull in *The Blood Covenant*. An example of blood covenanting still practiced by some tribes in Viet Nam is described by Homer E. Dowdy in *The Bamboo Cross* (New York: Harper & Row, 1964), pp. 87-116.

3. A covenant is a solemn pact that binds the actor to fulfill his promise. In Scripture, the term applies to various transactions between God and man, as well as man and his fellowmen. The covenant, and its various applications, is a subject too vast to cover in this study. Our purpose here merely is to point out the relationship between the blood and the covenanting principle. For coverage of all the aspects of a covenant, see G.E. Mendenhall, *Law and Covenant in Israel and the Ancient Near East* (Pittsburgh: The Biblical Colloquium, 1955); and Roderick Campbell, *Israel and the New Covenant* (Rome: Pontifical Biblical Institute, 1963). A good short treatment of the subject as related to the blood is in Morris, *The Apostolic Preaching*, pp. 65-111.

4. This record of the water and blood flowing from the pierced side of Jesus may indicate that He died from a broken heart. At least, this is the conclusion of many medical authorities. Apparently during the suffering on the cross, his heart swelled until it burst. The blood was effused into the enlarged sac of the pericardium, where it afterward separated into red clots and watery serum. When the distended sac was punctured by the soldier's spear, the water and blood discharged as described by John. See S.J. Andrews, *Life of Our Lord Upon the Earth* (New York: Charles Scribner, 1863), pp. 553-555; and David Smith, *The Days of His Flesh* (New York: Harper & Brothers), p. 506.

5. This passage is difficult to interpret with any degree of certainty. The reference here to the Spirit and the blood is clear enough, but the meaning of the water has invoked wide-spread speculation among New Testament students. In addition to the view that I have presented, the water might be seen as an allusion to the baptism of the prophet John and the sacrament of water baptism. The purifying aspect of the water as it points to Christ also is evident in the figure.

6. Because of the brevity of this reference, as well as its symbolic nature, there is ample room for speculation and difference of opinion. Why it was necessary that the pattern of things in the heavens should be cleansed is not explained. Some have conjectured that it was because sin originated in heaven with Satan, a condition that had its counterpart on earth with man's fall. Heaven as the scene of the Satanic conspiracy thus needed purification by the blood of the cross. A good presentation of this idea is by Daniel Steele, "Did Christ's Blood Decay?", in *The Advocate of Bible Holiness*, Dec., 1882, pp. 360-362. However, it must be said that this idea is only supposition. An undisputable reason, as in so many other matters of Biblical revelation, will have to await the day when we will no longer see through a glass darkly.

There is a fountain filled with blood
 Drawn from Immanuel's veins;
And sinners, plunged beneath that flood,
 Lose all their guilty stains.

The dying thief rejoiced to see
 That fountain in his day;
And there may I, though vile as he,
 Wash all my sins away.

Dear dying Lamb, Thy precious blood
 Shall never lose its power,
Till all the ransomed Church of God
 Be saved, to sin no more.

E'er since by faith, I saw the stream
 Thy flowing wounds supply,
Redeeming love has been my theme,
 And shall be till I die.

Then in a nobler, sweeter song,
 I'll sing Thy poor to save,
When this poor lisping, stammering tongue
 Lies silent in the grave.

WILLIAM COWPER

5
The Finished Work

The cry of the cross, "It is finished!" was the most thrilling word ever heard by men or angels. It was a mighty echo from the councils of eternity. Its meaning derived from all that happened before and since Jesus gave His blood for us. In making provision for the world to be saved, His mission was finished. The result of that sacrifice is set forth in the Scriptures many ways, some of which we shall now consider.

ATONEMENT ACCOMPLISHED

One benefit of the blood is *atonement*. The word in its simplest form means "to cover." For example, the pitch that Noah

was told to put on the Ark is the word for atonement (Genesis 6:14). It was the covering that held back the waters and made the occupants of the Ark safe. This gives a picture of what the atoning blood did on Jewish altars. It covered from God's view the sins of the people and held back His judgment.

This atonement, implied in all blood sacrifices (Leviticus 17:11), received particular emphasis on a special Day of Atonement.[1] It was observed annually as the climax of the Levitical year (16:1-34; 23:17-32; Numbers 29:7-11). On this occasion the whole nation was reminded anew that the continuance of their worship rested upon the virtue of the blood.

The ritual involved the High Priest slaying a bullock as a sin offering for himself and his family. Taking the blood into the Holy of Holies, he sprinkled it seven times before the Mercy Seat. Atonement was thereby made for himself and the inner sanctuary.

Returning to the open court, the High Priest walked between two goats that were stationed near the entrance. He drew two lots from an urn, laying one on the head of each animal. A scarlet cloth was tied to the horn of the goat designated as the Azazel, commonly called the "scape-goat." The other had a red cloth tied around his throat.

The High Priest then took another bullock, laid both his hands on its head, and confessed over it the sins of the priesthood. From the altar of burnt offering a censer was filled with burning coals, and these were taken with frankincense into the Holy Place. There he offered up the incense to God while he prayed for the nation. When at last the High Priest emerged from the sanctuary, he took some of the blood of the sacrifice and again went into the Holiest of all to sprinkle the Mercy Seat. Atonement was now made for the priests who served the altar.

Then he went out and killed the goat set apart for God. Entering a third time into the Holy of Holies, he sprinkled

the blood as before. The High Priest then took the vessel still containing some of the bullock's blood and sprinkled it before the veil seven times. This was repeated with the blood of the goat. Finally, mixing together the blood of the two animals, he sprinkled the altar of incense. Everything now about the worship of God was atoned for in blood.

This lesson was to have its greatest impact in the treatment of the other goat, which all during the service had stood before the congregation. At last coming to the waiting animal, the High Priest confessed over him the sins of all the people. The goat was then led away into the wilderness and released in a desolate place.

Symbolically this act represented the taking away of Israel's sin. The blood of the slain goat on the altar covered their transgression, but it "could not make him that did the service perfect, as pertaining to the conscience" (Hebrews 9:9). The perfecting of the conscience was represented by the live animal taken away.

Thus, in the ultimate sense, the Old Testament law never really removed sin; it only covered it in lieu of the perfect sacrifice to be offered by Christ (9:25-26). What the law could never do in its weakness, He has done by His grace. In Him the atonement is complete (Romans 5:11).

> Behold! the blest Redeemer comes,
> Th' eternal Son appears,
> And, at th' appointed time, assumes
> The body God prepares.
>
> No blood of beasts, on altars shed,
> Could wash the conscience clean;
> But the rich sacrifice He paid
> Atones for all our sin.
>
> ISAAC WATTS

Read the description of the Day of Atonement in
Leviticus 16:1-34. What spiritual principles
do you see in it?
How is atonement received today? Romans 5:11.
What does atonement mean in reference to Christ?

MERCY OBTAINED

Closely associated with the atonement of Christ is "propitia-
tion through faith in His blood" (Romans 3:25). It refers to
the provision made for God to show mercy to a sinner. Sin as
the repudiation of God necessarily invokes His judgment.
Anything that scorns His nature can not be ignored. Some-
thing must be done to remove the divine wrath incurred
because of sin.

In pagan religions, propitiation usually had reference to
what man could do to appease the offended deity—as if God
could be bribed by some offering. But this is not the concept
in the Bible. In the Testaments of Scripture, it is God who
takes the initiative in removing His wrath. A gift is offered,
but it is God who offers it in Christ. He gives His blood. The
gift is pleasing to the Lord because it displays His own glory
in that He sacrifices His life for the creature of His love.

This changes the whole nature of our salvation. God is
seen as both the subject and the object of propitiation. His
wrath is removed, not because we do something, but because
He did something. From beginning to end, it is a display of
His sovereign grace.

God hates evil, but He loves man. His love blazes
against that which would destroy His beloved—a love so
pure that it would not let us go even while we were yet
sinners. Such love can only be known in Christ. "In this is

love, not that we loved God, but that He loved us and sent His Son to be the propitiation for our sins" (1 John 4:10, NASB; cf., 2:2).

The word for *propitiation* literally can be translated "mercy seat" (Hebrews 9:5; cf., Exodus 25:17; 31:7; 35:12; 37:6; Leviticus 16:2,13). Reference probably is to the place above the Ark of the Covenant in the Holy of Holies where the blood of the atoning sacrifice was sprinkled. It was here that the *Shekinah* glory came down and filled the inner chamber with the presence of God.

The Mercy Seat covered the tables of the covenant (Hebrews 9:4; cf., Exodus 25:21). It was a perpetual reminder that salvation had not yet come in the flesh. Hence the Mercy Seat was hidden from their physical sight in the Holiest of all. Yet they could see it by faith, and in that manner they entered in with the High Priest when he sprinkled the Mercy Seat with blood.

In contrast to the old law, Christ's offering at the cross was not hidden from the view of the people. Rather He was set forth openly as a public spectacle "to be a propitiation for us" (Romans 3:25). The blood of Calvary now boldly invites us all to meet with God.

So let us come by faith. The wrath of the law is covered. God's hatred of sin is hidden in the depth of His love. At the Seat where mercy reigns, we have a place where we can flee for refuge, a place where our faith can lay hold of grace, a place where we are accepted in the Beloved.

> From every stormy wind that blows,
> From every swelling tide of woes,
> There is a calm, a sure retreat;
> 'Tis found beneath the mercy seat.
>
> There is a place where Jesus sheds
> The oil of gladness on our heads,

A place than all besides more sweet;
It is the blood-bo't mercy seat.

HUGH STOWELL

What is propitiation? 1 John 2:2; 4:10; Hebrews
9:5.

How can God's wrath be reconciled with God's
love?

Why is propitiation effected through faith in
Christ's blood? Romans 3:25.

A NEW RELATIONSHIP

The blood of Christ enables us to have a totally new relation-
ship with God. Both our relation to Him and His attitude
toward us are changed because of what happened at the cross.
God's nature is not changed. He is always the same, but the
way in which He looks at us is different.

One way of describing it is through *justification*. In this
figure Christ is represented as accepting our judgment by
taking unto Himself the wrath of the law. It is as though He
assumed our legal liability when he suffered the consequence
of our sin. By identifying with the nature of His blood, we
thus can be forgiven. It is a sovereign act of pardon, not
because of anything we have done, but for the sake of the Son
who loved us unto death.

When by faith we renounce all our claims of self-
righteousness and receive His grace, we stand before God
free of all sin. God sees us as we are in Christ, the Just One. In
Him there is no condemnation. "Much more then, having
now been justified by His blood, we shall be saved from the

wrath *of God* through Him" (Romans 5:9, NASB).

The concept of *reconciliation,* closely related to atonement, is another way to get at this truth. The idea is to bring together two parties that are separated. An atonement is effected through the blood. That sin which kept us apart is now removed. "For God was in Christ, restoring the world to himself, no longer counting men's sins against them but blotting them out" (2 Corinthians 5:19, TLB). The resulting relationship is one of harmony and peace. "For Christ's death on the cross has made peace with God for all by his blood." We who were once enemies of God, alienated in our mind by wicked works, He has brought back as "his friends" (Colossians 1:20-21, TLB).

The idea of the blood bringing the Gentile world to God reflects this same idea. Without Christ we were "strangers from the covenants of promise, having no hope" (Ephesians 2:12). But now in the Savior we "who formerly were far off have been brought near by the blood of Christ. For He Himself is our peace, who made both *groups into* one, and broke down the barrier of the dividing wall" (2:13-14, NASB). By His death the whole system of Jewish laws has been eliminated, so that in Him there is no longer Jew or Gentile. The long feud is ended. He has gathered us all up in Himself as one new person (2:12-16).

Here the blood is seen again as the means by which all believers, irrespective of race or position, can enter into the presence of God (Hebrews 10:19). Through this new and living Way we have no anxiety in approaching His throne. The blood of Christ has taken away all fear, and in its place there is peace, perfect peace, peace that passes understanding. Oh, the bliss of this communion. To rest in Christ!

We bless Thee, Jesus Christ our Lord;
For ever be Thy name adored:

For Thou, The sinless One, has died,
That sinners might be justified.

O very Man, and very God,
Who has redeemed us with Thy blood;
From death eternal set us free,
And made us one with God in Thee.

C. VISCHER

Study Romans 5:8-11. What is the meaning of
justification and reconciliation? How does
the blood make it possible?

In view of your relationship to God, what privi-
lege do you assume and why? 2 Corinthians
5:17-21.

How do you enter into the holiest through the
blood? Hebrews 10:22.

REDEEMED

At the time of the Civil War there was a band of organized
outlaws in the Southwest called the Quantrill Raiders. They
would sweep down upon an unsuspecting community on the
frontier to rob, pillage, burn, and then ride away before help
could come.

The situation became so desperate that some people in
Kansas formed a militia to search out the desperados. They
had orders to execute without delay any of the raiders that
could be found.

Not long afterward, a group of these men were captured.
A long trench was dug; they were lined up, hands and legs
tied, and eyes bandaged. The firing squad was forming.

Suddenly a young man rushed out of the underbrush, crying out, "Wait! Wait!" Covered by the guns of the firing squad, he approached the officer in command. He pointed to a man who was waiting to be shot, and said, "Let that man go free. He has a wife and four children, and is needed at home. Let me take his place. I am guilty."

It was an extraordinary appeal, but the stranger insisted that it not be denied. After a long consultation, the officers decided to grant the request. They cut the ropes and released the condemned man. The volunteer was put in his place, and fell dead before the firing squad.

Later the redeemed man came back to the awful scene of death, uncovered the grave, and found the body of his friend. He put it on the back of a mule and took it to a little cemetery near Kansas City, where he was given a proper burial. There he erected a memorial stone upon which were inscribed the words: HE TOOK MY PLACE. HE DIED FOR ME.[2]

In a much more profound way, that is what happened when Jesus died at Calvary. He took our place. We were all sold unto sin, under the sentence of death. But in God's incredible love, Jesus came forward and offered Himself as our Redeemer.

The word *redemption* means to buy back or to loose. As applied to man, it signifies the loosing of the bonds of a prisoner setting him free. Commonly, the term in Jesus' day referred to the amount required to purchase the life of a slave; or in a slightly different rendering, it might be used in the context of ransom where a sum of money was supplied as the condition for release.

The purchase price of our redemption was the blood of Christ (Ephesians 1:7; Colossians 1:14). His death became our ransom from sin (Matthew 20:28; 1 Timothy 2:6). We are "not redeemed with corruptible things, as silver or gold." Our redemption is in "the precious blood of Christ, as of a

lamb without blemish and without spot" (1 Peter 1:18-19; Hebrews 9:12).

Think of what this means! Bought with a price, we are no longer our own (1 Corinthians 6:19-20; 7:22-23). We belong to Him who purchased us with His own blood (Revelation 5:9; Acts 20:28). As Christ's bondslaves, we are now His treasured possession—His to keep, His to use, His to enjoy forever.

Nor silver nor gold hath obtained my redemption,
 Nor riches of earth could have saved my poor soul;
The blood of the cross is my only foundation,
 The death of my Savior now maketh me whole.
I am redeemed, but not with silver;
 I am bought, but not with gold;
Bought with a price—the blood of Jesus,
 Precious price of love untold.

JAMES M. GRAY

Meditate upon Ephesians 1:7, Colossians 1:14, 1 Peter 1:19, and Hebrews 9:12. What does redemption mean? How is it obtained?
Why is blood the price of redemption? To whom is the ransom paid?
As one bought with a price, what is your obligation to your Redeemer? 1 Corinthians 6:20; 7:22-24.

THE NEW PERSON

There is an inner transformation of character through redemption. One way the Scriptures express it is by "the

blood of Christ cleanseth from all sin" (1 John 1:7). This does not refer to mere forgiveness of sin, wonderful as that is. *Cleansing* denotes that ministry of the Holy Spirit on the inside purifying the heart. The guilt and pollution of sin are washed away by the blood (Revelation 1:5; 7:14).

An illustration of this principle is the old Levitical ritual for cleansing persons who had been contaminated by death. A red heifer without spot was sacrificed outside the camp (Numbers 19:1-22). The blood was taken by the High Priest's son and sprinkled seven times toward the sanctuary, after which the whole animal was burned. When the offering had been consumed by fire, the ashes were mixed with pure water, a hyssop dipped into the solution, and the unclean persons sprinkled. Upon washing themselves in water, their defilement was removed.

This ceremonial rite, observed by some people every time there was a death in Israel, was in the thinking of the author of Hebrews when he wrote, "If the blood of bulls and of goats, and the ashes of an heifer sprinkling the unclean, sanctifieth to the purifying of the flesh: How much more shall the blood of Christ, who through the eternal Spirit offered himself without spot to God, purge your conscience from dead works" (Hebrews 9:13-14).

Here the whole man is cleansed from sin's defilement by the blood-applying ministry of the Holy Spirit. There is a resulting sense of being clean all the way through. "Our hearts [are] sprinkled from an evil conscience, and our bodies washed with pure water" (10:22). We still have a corrupted fleshly nature and live in a depraved world with all its temptations to sin, but our spirit is clean. And as we continue to abide in Christ, walking in His light, His blood moment by moment keeps us pure.

In cleansing the heart, the Spirit imparts the divine nature of our Lord. Jesus suffered without the gate that "he

might sanctify the people with his own blood" (13:12). Sanctification implies conformity to the will of God by being set apart for His use, and thereby sharing in His life of holiness.

To this end Christ committed Himself to the mission of the cross, in order that we might be sanctified through the truth (John 17:19). His blood speaks of that complete alignment of His life with the will of the Father, and in the same manner it calls us to a life of full surrender and obedience (1 Peter 1:2).

The Spirit's supreme ministry is to reveal Christ, for to know Him aright is life everlasting. Hence the blood is the central focus of His work. Just as He enabled Jesus to offer up His life for us, so now He constrains us to give our life to Him. Beholding the face of Christ whom He exalts, we "are changed into the same image, from glory to glory, even as by the Spirit of the Lord" (2 Corinthians 3:18).

> Spotless, sincere, without offense,
> O may we to His day remain!
> Who trust the blood of Christ to cleanse
> Our souls from every sinful stain.
>
> Lord, we believe the promise sure.
> The purchased Comforter impart!
> Apply Thy blood to make us pure—
> To keep us pure in life and heart!
>
> CHARLES WESLEY

Read 1 John 1:7 in some modern translations.
Note the continuing action of the blood.
What does this say to you in reference to sin?
How does the blood relate to your conscience?
Hebrews 9:14.

What is sanctification as related to your experi-
ence of Christ? How does it happen? Hebrews
13:12.

MINISTERING SERVANTS

God cleans us up and breathes His life within us so that we
might be His *ministering servants.* We are sanctified to be
"meet for the master's use" (2 Timothy 2:21). The con-
science is cleansed so that we might "serve the living God"
(Hebrews 9:14). Christ "has washed us from our sins in his
own blood . . . And made us kings and priests unto God"
(Revelation 1:5-6). The washing and the ministering go
together. This result of cleansing continues on into heaven,
for those who have "washed their robes and made them white
in the blood of the Lamb" are seen "before the throne of God
and serve him day and night in his temple" (7:14-15). There
are no drones in His kingdom!

As priests of God, we are appointed to offer up spiritual
sacrifices pleasing in His sight. The office has special refer-
ence to mediation in behalf of others. Think of what this
means in terms of our prayer life. The blood that was offered
by Christ for us now binds us to His intercessory ministry for
the world. Here we enter most completely into the heart of
our Savior's love.

It was the custom in Biblical days for the Israelites to
bow in prayer outside the sanctuary while incense was placed
by the priest on the burning coals at the golden altar (Luke
1:8-10). The fire that burned the incense was taken from the
brazen altar where a sacrifice was offered. Their prayers thus
mingled with the ascending cloud of smoke in a beautiful
expression of faith and dependence upon the blood.

This is still the case. In the symbolism of the temple in Revelation, heaven has a golden altar upon which incense is offered with the prayers of the saints (Revelation 8:3-4; cf., 5:8). We can assume from this mystical figure that the fire that lifts the incense is taken from the altar where Christ gave His blood. It is here as our will is consumed with His that prayer has its ultimate purpose.

Our priestly office is coupled with a kingly authority and rule. This lofty designation suggests that we shall someday share in the reign of Christ in His kingdom (22:5; cf., 20:4; Luke 22:29). The position carries with it great honor and power. For the moment this may seem strange to us in this alien world where Christ has been rejected, but the day will come when every knee shall bow before Him, and His enemies shall be made a stool for His feet (Hebrews 10:12-13). Consider this the next time you are feeling discouraged. A king should hold his head high and walk with a dignity becoming his royal estate.

Whatever we do, it should be done to the glory of God (1 Corinthians 10:31; Colossians 3:17). His adoring worship finally is the whole purpose of our existence. It is not surprising then that praise is the language of heaven. When blood-washed hearts are living in the fullness of His presence, nothing else seems appropriate.

Sometime ago I noticed over the door of a church the inscription ENTER INTO HIS GATES WITH THANKSGIVING, AND INTO HIS COURTS WITH PRAISE (Psalm 100:4). I was impressed immediately with the admonition of the psalmist. Indeed we should always enter the church with joy and adoration. Then I remembered that these words have reference to the "sheep of the pasture" being led through the gates of Jerusalem into the courts of the temple. There they were to be offered as sacrifices upon the altar of God. That was their only purpose for coming into God's house.

He is talking about us. We are the sheep of the pasture (100:3). The only way to enter His holy temple is to offer ourselves as a living sacrifice on the altar of Christ. Is not this the reasonable service of us all? Christ wants all of us. Yet in this abandon we find the fullness of His joy and the blessedness of His ministry.

> Would you in His kingdom find a place of constant rest?
> Would you prove Him true in providential test?
> Would you in His service labor always at your best?
> Let Him have His way with thee.
> His power can make you what you ought to be;
> His blood can cleanse your heart and make you free;
> IIis love can fill your soul, and you will see
> Twas best for Him to have His way with thee.

CYRUS S. NUSBAUM

Why is cleansing in the blood so directly associated with service? Who is a ministering servant? Revelation 1:5; 7:14-15.

Read the account of the sacrifice and prayer in 1 Samuel 7:7-10. What does it mean to plead the blood?

Why is full consecration to Christ our only reasonable response to His grace? Romans 12:1-2; Galatians 2:20.

THE TRIUMPH OF THE CHURCH

Pleading the virtue of the blood before God makes us plead its power before men. We dare not divorce our standing in

heaven from our witness on earth. The blood that brought us
to God cries out for all to come. To keep the life-saving
gospel to ourselves is to repudiate its truth in practice. For
God gave His Son for the whole world, and He bids us go and
tell the story to those who have not heard. If we do not pass
the word along, God will hold us responsible for the blood of
those who die in their iniquity (Ezekiel 3:18; 33:4,6,8; cf.,
Acts 20:26).

This witness that we are to share is not to be confused
with special callings and gifts within the body of Christ.
Whether we serve as a pastor, farmer, or housewife is not the
issue. What matters is that we heed God's appointment and
serve Him with the ability that He has given. Though forms
of ministry will vary from person to person, all of us are
involved in the work of Him who bought us by His blood.

There will be hardships. The gospel of God's grace
always faces opposition from the proud principalities of this
evil world. All the hosts of darkness are arrayed against the
Church, and these satanic forces always seek to destroy our
witness. As long as we live in the flesh, we are engaged in a
holy warfare.

But the church militant will be triumphant. The death
of Christ has destroyed the works of the devil (1 John 3:8;
Hebrews 2:14). Satan is a defeated foe. The great Deceiver is
cast down. In describing the conquest, John says, "They
overcame him by the blood of the Lamb, and by the word of
their testimony; and they loved not their lives unto the
death" (Revelation 12:11).

The victory is in the blood, and it comes as this word is
proclaimed by a church willing to die for Christ. Such com-
mitment will shake the gates of hell, and ultimately prevail
over every obstacle to world evangelism. Then shall the
kingdom come to fruition in the glorious return of our Lord
(Matthew 24:14).

Have we lost something of this dedication and vision? In our affluence have we been prone to take the blessings of the blood without accepting its demands? If so, we should welcome adversity. Perhaps if we knew more of the rigors of battle, we would rejoice more in the promised victory. Or is it the other way around? If we had a clearer vision of the final triumph of the church, we would not fear so much its cost.

Of this we may be assured. Whatever it takes, the great commission will be fulfilled. The apostle wrote of his heavenly vision, "I beheld, and, lo, a great multitude, which no man could number, of all nations, and kindreds, and people, and tongues, stood before the throne, and before the Lamb, clothed with white robes, and palms in their hands" (Revelation 7:9). They were singing the praise of the Lamb.

It is clear from this description that someday the gospel of Christ will be heard to the ends of the earth. Those that believe will be gathered to a great homecoming in the sky. Their names are written in the Lamb's Book of Life (Revelation 3:5; 20:12; 21:27; 22:19; cf., Luke 10:20; Daniel 12:1; Exodus 32:33). What was in the mind of God before the worlds were made now will be revealed in the Light that is fairer than day (Revelation 13:8; 17:8; Ephesians 1:4).

There in the glory of Christ the church shall be joined with all the celestial hosts worshiping the Lamb for sinners slain. We shall know then far better what it means and have a much greater capacity to express our praise, but the testimony in heaven will be the same that saved us on earth—it is the blood—the precious blood of the eternal Son who gave His life for us that we might forever live our life in Him.

> O for a thousand tongues to sing
> My great Redeemer's praise,
> The glories of my God and king,
> The triumphs of His grace.

He breaks the power of canceled sin,
He sets the prisoner free;
His blood can make the foulest clean;
His blood availed for me.

CHARLES WESLEY

Why does the blood call us to evangelism? What happens if we do not accept our responsibility to others? Ezekiel 33:4-8. What did Paul mean when he said that he was free from the blood of all men? Acts 20:26.

How will the church finally triumph over all the power of darkness? Revelation 12:11. How do you see your own ministry in the light of the Great Commission?

Meditate upon the benediction of Hebrews 13:20-21.

NOTES:
1. In addition to the works already cited in reference to sacrifice, the Day of Atonement is described in *The Mishnah,* Yoma, pp. 162-172.
2. The essence of this story is authenticated from several sources as told by Billy Sunday in *Wonderful, and Other Sermons* (Grand Rapids: Zondervan), pp. 37-39.

When I survey the wondrous cross
 On which the Prince of Glory died,
My richest gain I count but loss,
 And pour contempt on all my pride.

Forbid it Lord, that I should boast
 Save in the death of Christ, my Lord;
All the vain things that charm me most,
 I sacrifice them to His blood.

See, from His head, His hands, His feet,
 Sorrow and love flow mingled down;
Did e'er such love and sorrow meet,
 Or thorns compose so rich a crown?

Were the whole realm of nature mine,
 That were a present far too small:
Love so amazing, so divine,
 Demands my soul, my life, my all.

 ISAAC WATTS

FEED THE CHURCH OF GOD,
WHICH HE HATH PURCHASED
WITH HIS OWN BLOOD.
ACTS 20:28

Conclusion

Our study of the blood is by no means finished. Undoubtedly many facets of truth have been turned over that need further research and clarification. But before this book is closed, I would like to make a few concluding observations.

1 *The blood of the human race ultimately flows into and out from the cross of Christ.* Every drop of blood in the veins of man from the beginning of time speaks of the life of God's Son poured out for us. Apart from this indisputable fact of history, our life would have no value or destiny.

2 *Supremely it is the blood of Christ's vicarious death that gives meaning to His life on this earth.* His incarnation in the flesh

was for the purpose of His atoning sacrifice. His experience from infancy to maturity was significant in that He demonstrated in human personality the reality of His sinless nature—a Lamb without spot and blemish. The resurrection, ascension, and heavenly reign of Christ have infinite importance because this same Savior died for our sins.

3 *Christ's blood reveals the eternal character of God.* The Son was slain in the heart of God before the foundation of the world. What transpired at the cross was already an accomplished fact in the determinate councils of eternity. It is God's nature so to love. The blood simply made known in time the perfection that is always true of God. If we want to know what God is like, let us look at Calvary. There is the clear revelation of His own heart.

4 *Shed blood proves that God cannot trifle with sin.* His holiness requires that anything unclean must die. Justice permits no exception. Thus Christ was slain. Though blameless, He identified Himself with us, and so bore our judgment. If there had been any other way by which He could have obtained our salvation, we may be sure that God would have done it. But there is no other way.

5 *The blood of Christ finally, completely and forever answers the problem of perishing man.* Jesus accepted in His body the penalty of our sin. He paid it all. However we may seek a theological explanation for it, the fact is that it happened. His act of love broke the bondage of death and hell. A perfect atonement was made for the human race. To every believing heart, His blood now offers a salvation that is full and free.

6 *By the blood we are brought to a crisis of decision.* We cannot be neutral before the cross. Beholding the bleeding Lamb of

God, every man must honestly face the question, Why? The blood demands an answer. Upon the verdict hangs the destiny of our immortal soul.

7 *The blood will not permit any compromise.* It is clearly a life totally offered to God. Half-hearted commitment will never be reconciled with the sacrifice of Him who gave all for us. Only as we learn the principle of dying to ourselves can we experience the fullness of His life. The outpouring of the Spirit always stands on the other side of the cross. Our understanding of His claims upon our lives will deepen as we grow in Him, but at any time we should be ready to obey all that we do know of His will. In this daily abiding of full obedience, we know the constant triumph of His resurrection.

8 *We must witness to the blood through our lives.* To accept its benefits brings us under its commission. As Jesus gave His blood to seal the gospel, so He sends us forth to proclaim it. Our mandate reaches to the whole world. In this ministry we are given a new sense of purpose for living. A thrill is put into every job. Whatever we do, we are messengers of good news.

9 *The gospel of the blood will always be an offense to this world.* Sometimes it may invoke hostility. Of course, some react out of ignorance of its meaning, and really do not mean to reject its truth. Still we should admit in all fairness that there is no way the blood can be made compatible with the egotistical wisdom of man. It says that human achievement is vanity. Those who are infatuated with a sense of their own goodness naturally will look upon the blood as a stumbling block. Others who view religion only in terms of beautiful ideals divorced from the realities of life will regard the cross as foolishness. We might as well face it. Proud man resents the testimony of the blood against human sufficiency!

10 *But those who have come to the end of all human resources will hear of Christ's blood with tears of thanksgiving and shouts of joy.* It is the witness of divine grace. When our hearts are broken and mercy is our only hope, then the blood of Christ is seen as the wisdom and the power and the glory of God.

There is a legend of a rich man seeking entry into heaven. As he stood at the gate, an angel asked him to give the password. The finely dressed gentleman replied, "I have contributed generously to the church. My morality is beyond dispute. Everywhere I am respected among men. Surely I have earned a place in heaven."

But the angel answered, "This is not the password. You cannot enter."

As the famous benefactor was turned away, another man of distinguished appearance knocked on heaven's door. Challenged by the angel to give the password, he replied, "I have served the Lord as a minister of the cloth. I have performed great works of righteousness in His name. Renowned institutions have honored me with their highest degrees. I deserve heaven's favor."

But the angel answered, "That is not the password. You do not know the King."

No sooner was the man cast out than an old woman approached the gate. Her body was bowed from many years of toil. But there was a twinkle in her eyes and a shine on her face. Asked by the angel to give the password, she lifted up her hands and started to sing:

> The blood, the blood, is all my plea.
> Hallelujah! It cleanseth me!
> Hallelujah! It cleanseth me!

Immediately the gates of pearl swung open, and as the

dear spirit entered into the celestial city, the choirs of heaven joined in singing her song.

The theology of this old story may be oversimplified, but the point can not be missed. When all is said, our only claim to heaven is the blood of Jesus Christ. Here is the password into the presence of God, now and forever.

> My lasting joy and comfort here
> Is Jesus' death and blood;
> I with this passport can appear
> Before the Throne of God.
> Admitted to the realms of bliss,
> I then shall see Him as He is,
> Where countless pardoned sinners meet
> Adoring at His feet.

CHRISTIAN RENATUS VON ZINZENDORF